Scanning and Editing Your Old Photos

PEARSON

Harlow, England • London • New York •
Tokyo • Seoul • Taipei • New Delhi • Cap

Kong
Milan

PEARSON EDUCATION LIMITED

Edinburgh Gate
Harlow CM20 2JE
Tel: +44 (0)1279 623623
Fax: +44 (0)1279 431059
Website: www.pearson.com/uk

First published in Great Britain in 2012

ISBN: 978-0-273-76259-1

British Library Cataloguing-in-Publication Data
A catalogue record for this book is available from the British Library

Library of Congress Cataloging-in-Publication Data
A catalog record for this book is available from the Library of Congress

10 9 8 7 6 5 4 3 2 1
15 14 13 12 11

Typeset in 11/14pt ITC Stone Sans by 3
Printed and bound in Great Britain by Scotprint, Haddington, East Lothian

Scanning and Editing Your Old Photos

in Simple steps

Heather Morris

Use your computer with confidence

Get to grips with practical computing tasks with minimal time, fuss and bother.

In Simple Steps guides guarantee immediate results. They tell you everything you need to know on a specific application; from the most essential tasks to master, to every activity you'll want to accomplish, through to solving the most common problems you'll encounter.

Helpful features

To build your confidence and help you to get the most out of your old photos, practical hints, tips and shortcuts feature on every page:

ALERT: Explains and provides practical solutions to the most commonly encountered problems

HOT TIP: Time and effort saving shortcuts

SEE ALSO: Points you to other related tasks and information

DID YOU KNOW? Additional features to explore

WHAT DOES THIS MEAN?

Jargon and technical terms explained in plain English

Practical. Simple. Fast.

in Simple steps

Dedication

For David

Acknowledgements

I'd like to thank my family for sharing many of their old photographs and slides. I'm grateful for the ongoing support of Neil Salkind and Joli Ballew. Thanks also to the Celli family for so generously lending me their black and white photographs.

The publisher would like to thank the following for permission to reproduce copyright material:

Photographs

Pages 2 and 17 Pearson Education Ltd. John Barlow; Pages 4 and 31 © Tetra Images/ Alamy; Pages 20 (right), 86, 87 © Plustek; Page 21 (top left and bottom left) Pearson Education Ltd. National Geophysical Data Center; Page 21 (top right) Pearson Education Ltd. Secretariat of Tourism, Buenos Aires; Page 22 (right), © fine art/ Alamy; Page 23 (right) © Oleg (RF)/ Alamy; Page 103 © Kevin Wheal/ Alamy; Page 155 © Ray A. Key/ Alamy.

Screenshots

Pages 25 and 67 (top and right), 68, 69, 70, 125, 126, 127, 128, 150, 151 © Irfanview; Page 27 © cnet UK; Pages 88, 89, 90, 91, 92, 93, 94, 95, 96, 97, 98, 99, 100 © Lasersoft Imaging; Pages 163, 164, 165, 166 © Google; Pages 167, 168, 169, 170, 171, 172 © Tesco Stores Limited.

In some instances we have been unable to trace the owners of copyright material, and we would appreciate any information that would enable us to do so.

Contents at a glance

Top 10 Scanning and Restoring Tips

1 Choose your scanner and editing software

- Determine your scanning needs 17
- Explore scanner types 20
- Purchase and install a scanner 23
- Purchase and install the software 27

2 Perform a simple scan

- Start your scanner 33
- Preview your scan on a flatbed scanner 35
- Perform a quick scan with a flatbed scanner 36
- Save your scan 40

3 Adjust scan results using your scanner

- Preview your image 45
- Adjust brightness and contrast 50
- Adjust image resolution 51
- Change the orientation of the image 53

4 Adjust results with editing software

- Use automatic adjustments 59
- Crop your scanned image 62
- Remove red-eye 64
- Repair torn or blemished images with the clone tool 65

5 Scan slides and film with an adapted flatbed scanner

- Adapt your scanner 73
- Place your negative film 74
- Place your film holder in the scanner 75
- Adjust the image and scan 78

6 Scan with a dedicated film scanner

- Perform a prescan of your negative 88
- Scan and save your negative 93
- Scan and save your slide image 98
- Apply auto adjust 99

7 Batch scan photographs and film

- Sort compatible photos and film 103
- Apply adjustments to your batch 107
- Preview slides or negatives for batch scan 110
- Scan and save your batch slides 113

8 Perform special scans and editing projects

- Scan older grayscale photographs 117
- Scan and save a file as a TIFF 122
- Repair damage with the healing brush 123
- Stitch and save an oversized image 132

9 Organise your scans

- Create a naming system 137
- Set up folder options 138
- Tag your images with Photo Gallery 142
- Archive images to disc 146

10 Use your scans

- Save to an SD card for use with a digital frame 155
- Publish your images on the Internet 163
- Share your web album 165
- Upload images for printing 168

Top 10 Scanning and Restoring Problems Solved

Contents

Top 10 Scanning and Restoring Tips

1	Determine your scanning needs	2
2	Understand image resolution	3
3	Clean your scanner	4
4	Understand file formats	5
5	Preview your image	6
6	Use automatic adjustments	7
7	Remove red-eye	8
8	Adjust colour saturation	9
9	Repair damage with the healing brush	10
10	Archive images to disc	12

1 Choose your scanner and editing software

• Determine your scanning needs	17
• Review your computer's minimum resources	18
• Understand image resolution	19
• Explore scanner types	20
• Consider how much editing you'll need to do	21
• Know what to do if you don't have a computer	22
• Purchase and install a scanner	23
• See what your scanner software offers	24
• Compare free options	25
• Compare low-cost software	26
• Purchase and install the software	27

2 Perform a simple scan

- Clean your scanner 31
- Clean your printed photo 32
- Start your scanner 33
- Place the photo appropriately 34
- Preview your scan on a flatbed scanner 35
- Perform a quick scan with a flatbed scanner 36
- Use Windows Fax and Scan 37
- Connect your standalone scanner to your computer 38
- Perform a quick scan with a standalone scanner and computer 39
- Save your scan 40
- Understand file formats 41

3 Adjust scan results using your scanner

- Preview your image 45
- Apply dust removal 47
- Apply Color Restoration 48
- Fix backlighting 49
- Adjust brightness and contrast 50
- Adjust image resolution 51
- Enlarge your image 52
- Change the orientation of the image 53

4 Adjust results with editing software

- Open your scanned image in editing software 57
- Use automatic adjustments 59
- Rotate your image 60

● Crop your scanned image 62

● Straighten your image 63

● Remove red-eye 64

● Repair torn or blemished images with the clone tool 65

● Adjust brightness and contrast 67

● Adjust colour saturation 68

● Increase the size of your image 69

● Frame your scanned image 70

5 Scan slides and film with an adapted flatbed scanner

● Adapt your scanner 73

● Place your negative film 74

● Place your film holder in the scanner 75

● Preview your negative scans 76

● Adjust the image and scan 78

● Place your slides 79

● Preview your slides 80

● Adjust the image and scan 81

6 Scan with a dedicated film scanner

● Sort your film 85

● Place negatives in the film holder 86

● Place the film holder in the scanner 87

● Perform a prescan of your negative 88

● Adjust size and resolution 90

● Correct brightness, contrast and colour saturation 92

● Scan and save your negative 93

● Place your slides in the film holder 94

Place the slide holder in the scanner 95

Perform a prescan of your slide 96

Adjust the slide image 97

Scan and save your slide image 98

Apply auto adjust 99

Apply dust and scratch removal 100

7 Batch scan photographs and film

Sort compatible photos and film 103

Align photos on the scanner 104

Preview images 105

Rotate your batch 106

Apply adjustments to your batch 107

Set the scan area for your batch 108

Scan and save your batch 109

Preview slides or negatives for batch scan 110

Adjust your batch scan of slides 111

Select output size 112

Scan and save your batch slides 113

8 Perform special scans and editing projects

Scan older grayscale photographs 117

Evaluate your image histogram 118

Adjust the histogram 120

Scan and save a file as a TIFF 122

Repair damage with the healing brush 123

Convert your image to sepia 125

● Add text to your image 127
● Scan a half-tone image 129
● Scan an oversized image 130
● Stitch and save an oversized image 132

9 Organise your scans

● Create a naming system 137
● Set up folder options 138
● Create new folders 139
● Rename your files 141
● Tag your images with Photo Gallery 142
● Move images to a new folder 143
● Copy images 144
● Archive images to disc 146
● Create an inventory for your disc 148
● Convert file format 150

10 Use your scans

● Save to an SD card for use with a digital frame 155
● Put photos in Movie Maker 157
● Edit your photo movie 159
● Save and share your movie 161
● Publish your images on the Internet 163
● Share your web album 165
● Register with an online photo centre 167
● Upload images for printing 168
● Order prints online 170
● Create photo gifts 172

Top 10 Scanning and Restoring Problems Solved

1 I'm getting a message that says my scanner isn't recognised or
 connected 174
2 My previewed scan has the wrong scan area around it 176
3 I can't batch scan my photographs 177
4 My scanner is slow or not working properly 178
5 My scanned photograph is blurred 180
6 It's difficult to make out details on my monitor 181
7 I'm not happy with my scans of black and white photographs 183
8 I can't repair my damaged older photographs 185
9 I want to resize my image to send it via email 186
10 I'm running out of memory on my computer 188

Top 10 Scanning and Restoring Tips

1	Determine your scanning needs	2
2	Understand image resolution	3
3	Clean your scanner	4
4	Understand file formats	5
5	Preview your image	6
6	Use automatic adjustments	7
7	Remove red-eye	8
8	Adjust colour saturation	9
9	Repair damage with the healing brush	10
10	Archive images to disc	12

Tip 1: Determine your scanning needs

The first step you need to take to commit your photos to the digital world is to look at your collection of prints and film. The types of images you have and your plan for using their digitised versions will help you decide what kind of scanner you need.

1 Gather the images you want to scan, and sort them by type: prints, slides, negatives.

2 Decide whether you want the scanned images to be available for printing, display on the Web, or some other project.

3 Make note of images that are in need of repair.

4 Consider how much work space you have for a scanner.

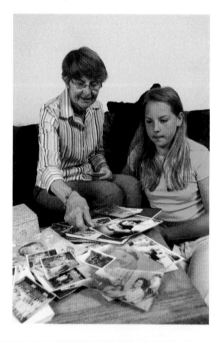

 HOT TIP: Culling the best images while you take an inventory will save time later.

 HOT TIP: The quality of image from a slide or negative is significantly better than from a print. If you have a valued image on slide or negative, scanning those will give you better results.

Tip 2: Understand image resolution

Image resolution is measured in dots per inch (dpi). A scanner will capture so many dots for each inch of the image. The greater the dpi, the higher quality the image will be. Keep the following in mind when considering the dpi capability of your scanner:

- Most printed photos can be scanned at 300–600 dpi with good results.
- Film and negative scanning require a much higher dpi.
- Dpi can be listed as two numbers or just one (600 × 1200 or 600)

The first image is scanned at 50 dpi and the second image at 600 dpi. Notice the difference in quality.

 DID YOU KNOW?

The first number refers to the dpi captured across the horizon of the image while the second refers to the dpi along the vertical plane of the image. Some manufacturers list only one number (e.g. 600) which will always refer to the dpi across the horizon of the picture.

 HOT TIP: Low resolution images (less than 150 dpi) are ideal for email and web use.

ALERT: Resolution may also be listed as ppi (pixels per inch); these two terms are often used interchangeably.

Tip 3: Clean your scanner

Tiny particles of dust, dirt and fingerprints can show up on your scan – even more so when you are doing high-resolution scans. Start with a clean scanner as this improves your image quality and prolongs the life of your scanner.

- Avoid using common household cleaners.
- Use a computer monitor wipe or other soft, anti-static wipe.
- Avoid touching the glass whilst cleaning.
- Check if the manufacturer recommends a cleaning product (otherwise, stick with the steps above).

ALERT: Even window cleaners can leave residue on your scanner's glass which will affect the quality of the scan.

 HOT TIP: If you have a flatbed scanner, leave the cover closed when not using it to protect the glass from debris.

ALERT: If you are using a standalone or sheet-fed scanner, use a sleeve to protect the scanner and photo during the scanning process. The protective sheet is usually included in the original box.

Tip 4: Understand file formats

There are several different file formats you can save your scans in. The two most common are JPEG (.jpg) and TIFF (.tif). Most of the time, your images will be automatically saved as JPEGs but there are circumstances when you will want to save a file as a TIFF.

1 Use JPEG for printing images, sending images via email and web use.

2 Use TIFF when you have a special editing project (such as an enlargement) or when you have a high-quality image that you want to preserve.

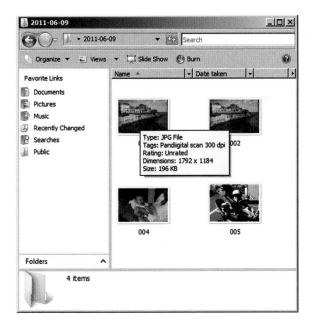

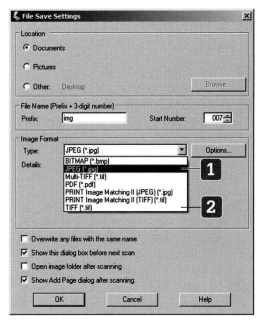

ALERT: TIFF file format creates much larger files than JPEG.

ALERT: Some of the data in the image is lost, or compressed, each time you save it as a JPEG file.

HOT TIP: If space is a concern on your computer, save the image as a JPEG.

Tip 5: Preview your image

You can get an idea of what adjustments can be made with your scanner by starting each scan with a preview. Most scanner software offers some preview options and good software allows you to see the changes to your image before you scan.

1 Place your photo on the scanner and start the software.

2 Check you are in Home Mode in Epson Scan.

3 Select Photograph under document type.

4 Select Image Type (Color, Grayscale, Black & White).

5 Click Preview.

6 Assess the image on screen, looking for the following types of issues:

a Too dark (underexposed).

b Too light (overexposed).

c Poor colour saturation.

d Dust embedded on the image.

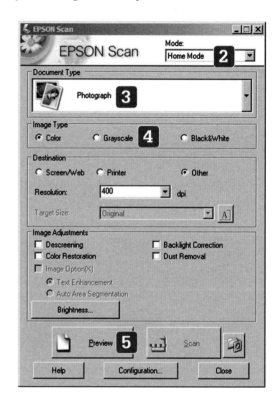

ALERT: Most software is set to default to colour images. If you are scanning a black and white photo or a grayscale photo, you must select those image types before your preview.

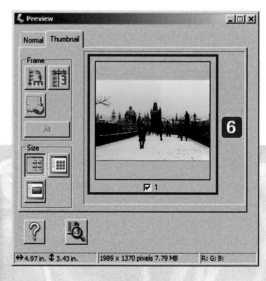

DID YOU KNOW?
You can choose whether or not you want the software to automatically adjust the image for you when you select Auto Mode in Epson Scan; colour restoration and dust removal are examples of problems that can be automatically adjusted for you.

Tip 6: Use automatic adjustments

If you have a large number of scans to edit, you may not have the time to work on each one in any depth. There are good automatic fixes that will enhance your scanned image quickly.

1 Open your image in your editing software.

2 Click Auto Enhance.

3 Click Apply.

4 Click Save or Save As.

5 Name your file and save it in a location you will remember.

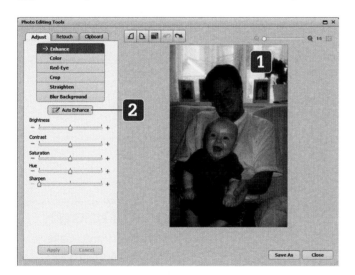

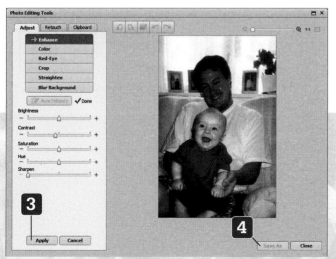

Tip 7: Remove red-eye

Red-eye occurs with annoying frequency for the average photographer. While there are steps to take to avoid red-eye problems, all editing software offers red-eye fix problems that take only seconds to apply.

With your image open in the editing software:

1 Click Red-Eye.

2 Click Fix Red-Eye.

3 Click Save As.

4 Name and save your image to a file of your choice.

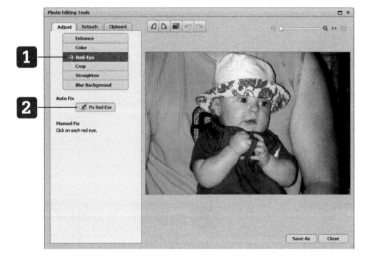

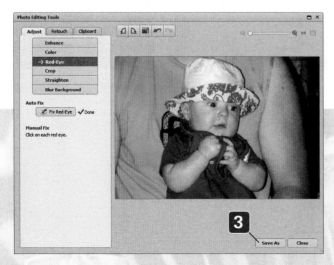

? DID YOU KNOW?

In Windows Photo Gallery click on Fix and a repairs tool bar will appear to the right. Click the Fix Red-Eye tool then click and drag your cursor to each eye to adjust.

Tip 8: Adjust colour saturation

Image colours can fade over time or perhaps the photo was always a little washed out. You can improve on the original by adjusting the colour saturation. Saturation simply refers to the purity and intensity of the colour in the image. Very dull photos have low colour saturation.

1 Double-click to launch the software.

2 Select File then Open to find the image you want to edit.

3 Click Image from the menu bar and select Color corrections.

4 Click and drag on the Saturation scroll bar to adjust.

5 Click Apply to original.

6 Click OK.

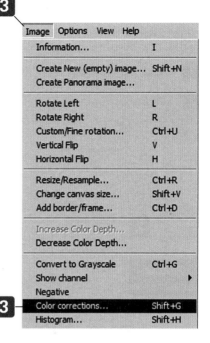

? DID YOU KNOW?

Some software programs have an auto adjust option for colour saturation which will make adjustments for you.

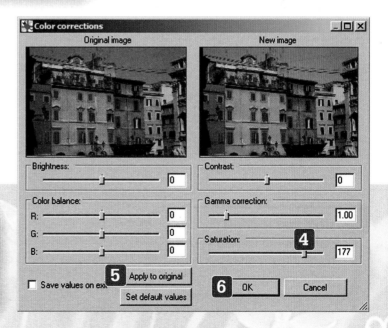

? DID YOU KNOW?

If you set the colour saturation to zero, the image will be in grayscale.

Tip 9: Repair damage with the healing brush

The healing brush is similar to the clone tool but you can achieve more subtle results with it. If your photograph has a lot of damage, this can be a time-consuming repair but one that should prove rewarding. While you get the hang of the tool, you can make use of the Undo button as frequently as you need.

1 Open your image in MediaImpression.

2 Select Retouch and click on the healing brush.

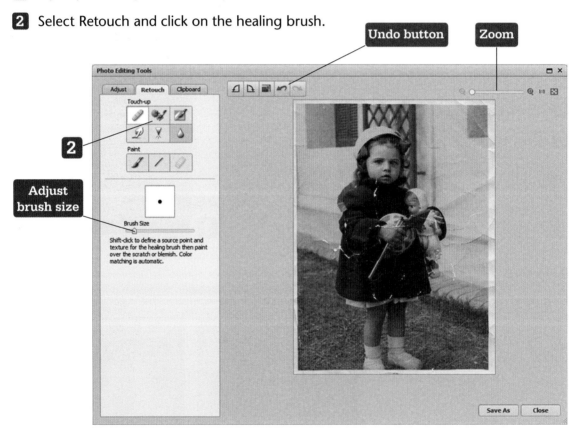

Undo button

Zoom

2

Adjust brush size

HOT TIP: Redefine the source as you work to keep the highlights and shadows in the image consistent.

3 Shift-click to copy a source to repair the damage with.

4 Zoom into an area you want to work on and click over it with the healing brush.

5 Adjust the brush size if needed by clicking and dragging on the scroll bar under the Brush Size image.

6 Click Save As when you are happy with the changes.

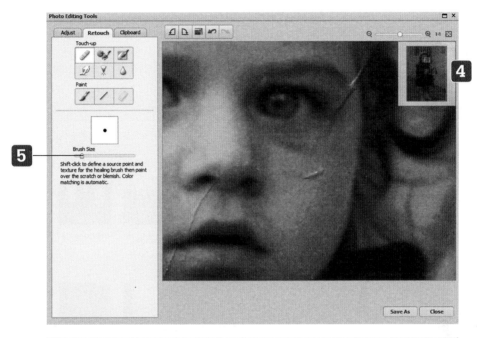

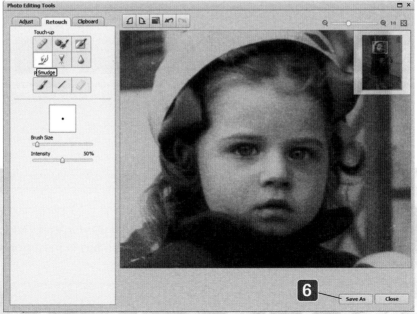

Tip 10: Archive images to disc

You can free up space on your computer by archiving your digital images to disc. Most Windows systems come with a Burn function which allows you to copy files onto disc. If you have a very large number of images you can save up to 4GB of files on a DVD. If you want to save a smaller number of files, use a CD which only holds 600–800MB.

1 Open the folder you want to save to disc.

2 Click Burn.

3 Insert a writable disc (like a CD-R) into the appropriate drive when prompted.

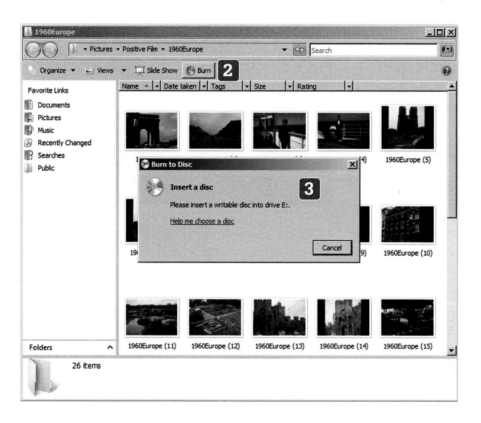

WHAT DOES THIS MEAN?

Writable disc: one that has been formatted to allow you to copy files (images, music, etc.) from your computer. A CD-R is a type of writable disc that you can buy in most stores – including supermarkets – and is ideal for saving images.

4 Type in a name for the disc and click Next.

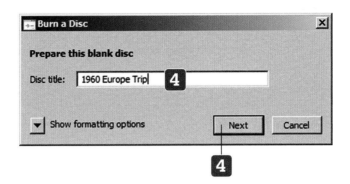

5 Wait while your images copy.

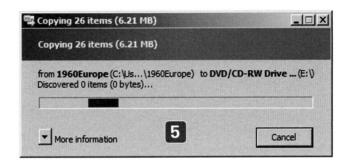

 HOT TIP: If room on your computer is very limited, consider deleting the images after saving them to two discs. Have two copies in case something happens to one of them.

HOT TIP: You can check the size of your folder by right-clicking on it and selecting Properties.

? DID YOU KNOW?

If you don't have a burn option on your folders, you can download free burn software. Use a trusted source like cnet (http://download.cnet.com/windows/cd-burners/) where you can see lots of options, reviews and editor recommendations.

1 Choose your scanner and editing software

Determine your scanning needs 17

Review your computer's minimum resources 18

Understand image resolution 19

Explore scanner types 20

Consider how much editing you'll need to do 21

Know what to do if you don't have a computer 22

Purchase and install a scanner 23

See what your scanner software offers 24

Compare free options 25

Compare low-cost software 26

Purchase and install the software 27

Introduction

Most people have a cupboard full of unfiled photographs and film or old albums in varying stages of decay. Scanning and editing these items will enable you to preserve and improve these images, share them with family and create a permanent digital archive of your memories. First you need to find a scanner and editing software that will meet your needs. Many options exist for both so you need to consider what you want from your scans and how much time and money you are willing to spend. The options range from simple one-touch machines to sophisticated devices and software that will give you amazing results. This chapter will help you determine what is best for you.

Determine your scanning needs

The first step you need to take to commit your photos to the digital world is to look at your collection of prints and film. The types of images you have and your plan for using their digitised versions will help you decide what kind of scanner you need.

1 Gather the images you want to scan, and sort them by type: prints, slides, negatives.

2 Decide whether you want the scanned images to be available for printing, display on the Web or some other project.

3 Make note of images that are in need of repair.

4 Consider how much work space you have for a scanner.

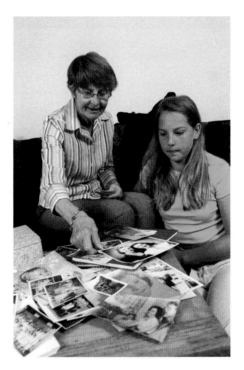

 HOT TIP: Culling the best images while you take an inventory will save time later.

 HOT TIP: The quality of image from a slide or negative is significantly better than from a print. If you have a valued image on slide or negative, scanning those will give you better results.

Review your computer's minimum resources

Chances are that you will choose a scanner that connects to your computer. You therefore need to determine your computer's capabilities to make sure it will work with your preferred scanner.

1 Click Start.

2 Note the operating system in use (such as Windows 7 or Windows XP), and the amount of RAM, or memory.

▶ **SEE ALSO:** Scanning without a computer is discussed in 'Know what to do if you don't have a computer' later in this chapter.

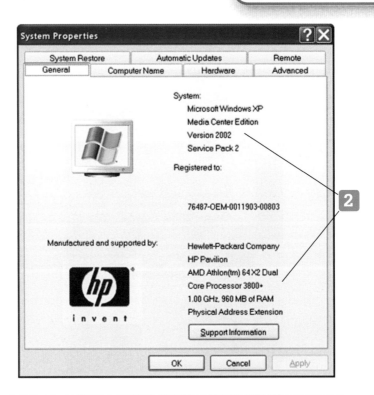

WHAT DOES THIS MEAN?

RAM: stands for *random access memory*, the portion of the computer's memory where the operating system and active applications and the data they are using are stored.

⚠ **ALERT:** Images use a fair amount of disk storage, so make sure you have a few gigabytes of storage space just to be sure.

Understand image resolution

Image resolution is measured in dots per inch (dpi). A scanner will capture so many dots for each inch of the image. The greater the dpi, the higher quality the image will be. Keep the following in mind when considering the dpi capability of your scanner:

- Most printed photos can be scanned at 300–600 dpi with good results.
- Film and negative scanning require a much higher dpi.
- Dpi can be listed as two numbers or just one (e.g. 600 × 1200 or 600)

The first image is scanned at 50 dpi and the second image at 600 dpi. Notice the difference in quality.

? DID YOU KNOW?

The first number refers to the dpi captured across the horizon of the image while the second refers to the dpi along the vertical plane of the image. Some manufacturers list only one number (e.g. 600) which will always refer to the dpi across the horizon of the picture.

 HOT TIP: Low resolution images (less than 150 dpi) are ideal for email and web use.

! ALERT: Resolution may also be listed as ppi (pixels per inch); these two terms are often used interchangeably.

Explore scanner types

Your scanner options include flatbed scanners, flatbed scanners with attachments for film or slides, film scanners and a few specialised scanners. When you visit a big electronics store or browse online, keep in mind your computer's capabilities, what sort of resolution you need and how much work space you have.

- Choose a flatbed scanner if you expect to scan mostly printed images.
- Choose a flatbed scanner with a transparent media adapter (TMA) if you have slides or film to scan in addition to prints.
- Choose a dedicated film scanner if you expect to scan *only* negatives or slides.

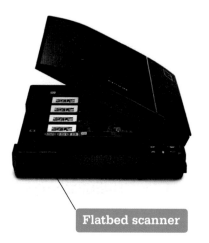

Flatbed scanner

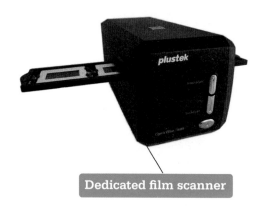

Dedicated film scanner

ALERT: Some easy-to-use scanners allow you to scan large quantities of 4-inch by 6-inch prints, but these scans will be suitable only for on-screen viewing, not for printing.

? DID YOU KNOW?
If you have numerous prints larger than A4 or 8 inches by 11.5 inches to scan, you may want to consider a large-format scanner.

ALERT: Multifunction office machines can copy, fax and scan photos but may not have the software to get the results you want.

Consider how much editing you'll need to do

Most scanners come with some image-editing software. Often the supplied software is adequate, but if you have more complicated needs or enjoy having high levels of control, you may need to consider different software – or a scanner that comes with the software you want.

1 Take a look at that photo inventory you assembled.

2 Review the photos to get an idea of what proportion of them require editing.

3 Assess how many need to have cracks or scratches repaired.

 HOT TIP: Manually editing photos can be a slow and tedious process. Look for a scanner that does a good job of automatically addressing the most common repairs.

? DID YOU KNOW?
Many scanners do an excellent job of automatically addressing such problems as red-eye from flash. (Red-eye is covered in Chapter 4.)

HOT TIP: Check to see whether a scanner lets you create custom repair settings that fit your needs.

Know what to do if you don't have a computer

You might want to scan photos even if you don't have a computer – perhaps to print out for relatives – or do not want to fiddle with connecting a scanner to your computer. Not to worry. You can still scan photos; you just won't have as many options for editing them.

1 Look for *standalone* scanners at your retail store or online.

2 Check that you have the necessary memory device for saving your scans, as this may or may not be included with your standalone scanner.

3 Find out whether you need an adapter to download your pictures from the card to another device.

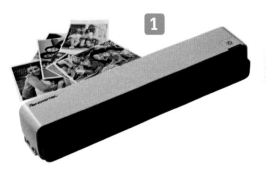

 DID YOU KNOW? Standalone scanners may save to an SD memory card (shown here) or a USB drive.

 HOT TIP: Some standalone scanners have small screens that allow you to view your scan, a nice feature if you aren't reviewing on a computer.

HOT TIP: You can use the SD memory card from your standalone scanner in your digital photo frames.

 HOT TIP: Many standalone scanners are portable, which can be very handy if you want to scan Aunt Tilly's photos but she won't let you take them with you.

 SEE ALSO: If you have a very large collection of images that you do not want to edit, you can send your photos, film and negatives to service providers who will do your scanning for you.

Purchase and install a scanner

Now that you have made your scanner selection, it's time to buy your machine and put it to work. Fortunately, installation is easy.

1 After buying your scanner, unpack its box and check the contents against the packing list that came with it.

2 Read the Quick Start guide that came with your scanner, and follow the installation instructions there.

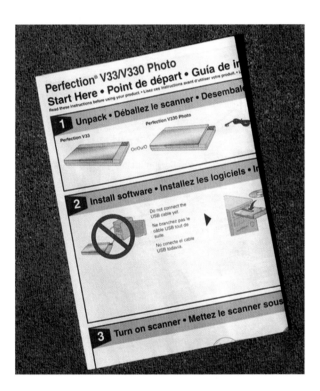

HOT TIP: If you cannot find a Quick Start guide, you generally follow these steps: insert the power cord into the scanner and then into the power strip; insert the USB cable (shown below) into the scanner, then into your computer; power on the scanner; the computer should 'see' the scanner within a few moments.

ALERT: If anything is missing, contact the seller immediately or return the entire package to the seller to get the missing item or a substitute package.

ALERT: Your scanner may require you to install software first. Insert the disk that came with the scanner, and follow the installation instructions. When in doubt, go with the default installation.

See what your scanner software offers

Your scanner will come with software that operates the scanner, and it may also include software that will help you adjust and edit your images both while you scan and afterwards.

1 When shopping, check the scanner's specifications or packing list to determine what software is included.

2 If the documentation lists no software, the scanner probably includes only the software needed to scan and save photos but not to edit them.

What's In the Box

Check the package for the following items. If there is any item missing or damaged, please contact your place of purchase immediately.

- Photo Scanner
- AC Power Adapter
- Printed User Guide and Warranty Card
 - SD Memory Card
- Calibration Card
- Two Plastic Protection Sleeves
- Roller Cleaning Sheet
- Sensor Cleaning Swab
- USB Cable

 HOT TIP: Many software programs allow you to affect the results as you scan, as well as to adjust images after you've scanned.

? DID YOU KNOW?

Some flatbed scanners also come with optical character reading (recognition), or OCR, software, which allows you to scan text documents and convert them into editable word-processing documents.

Compare free options

In addition to the software that may come with your scanner, you might want to experiment with a different program for editing your images once you have scanned them. Many free programs are available to download from the Internet and allow basic editing actions such as cropping, colour adjustment and re-sizing.

Some of the free photo imaging programs are web-based and work best if you have a fast Internet connection. Paint.net is an example of this.

- **IrfanView:** http://www.irfanview.com/
- **Google Picasa:** http://picasa.google.com/
- **Paint.net:** http://www.getpaint.net/download.html
- **GIMP:** http://www.gimp.org/
- **Fotografix:** http://lmadhavan.com/software/fotografix/

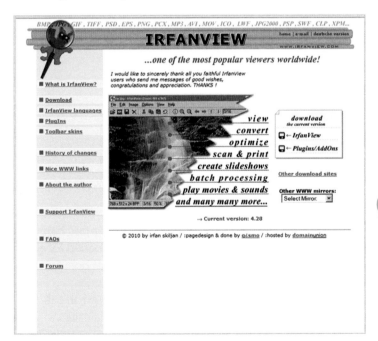

 DID YOU KNOW?

Many of the web-based editing programs allow you to share your photos on the Internet with family and friends, as well as store and organise your photos.

 SEE ALSO: There are more free options available than can be listed here. If you want more information on image editors and a comparison of their features, go to http://en.wikipedia.org/wiki/Comparison_of_raster_graphics_editors

 HOT TIP: If you have a fast Internet connection, you may not need editing software on your computer at all!

Compare low-cost software options

Free image-editing software is often limited in its abilities or may not have good documentation. High-end software, however, can be so expensive and complicated as to deter all but professional users. Some low-cost options seek a middle ground.

- Microsoft Digital Image Suite is one of the lower-cost options available and is popular with Windows users.
- Corel Paint Shop Pro is a long-time favourite of amateur photographers and is priced similarly to Microsoft's software.
- Photoshop Elements is the most costly of the three but boasts many of the features of the professional editing software, Adobe Photoshop.

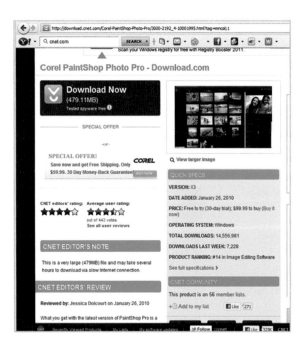

HOT TIP: Nearly all for-purchase software can be downloaded for a 30-day free trial. Look at popular websites such as www.cnet. com and www.zdnet.com, in the download section of their sites.

SEE ALSO: 'Purchase and install software' later in this chapter.

? DID YOU KNOW?

If you are keen to have professional level editing software to work with, Adobe Photoshop is the very best there is. However, it is expensive, takes up a lot of your computer's resources and can be a challenge to learn.

Purchase and install the software

Now that you've made at least a preliminary decision on what software you need, you can acquire and install it. Given the free software and free trials available, you can try one or two without spending any money at all.

1 Go to your favourite software download site, such as http://download.cnet.com/

2 Enter the software name into the search field and hit enter.

ALERT: Check the memory requirements of the download against the existing memory on your computer.

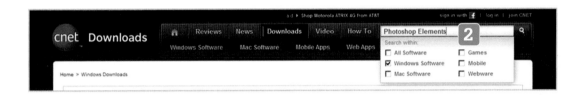

3 Find and click Download Now (or the equivalent).

4 Complete the download according to your operating system's usual steps.

5 Click the install button and follow the steps to complete the installation.

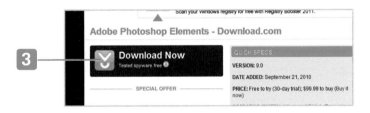

ALERT: Depending on your settings and the site, you may need to disable your browser's pop-up blocker. Watch for a yellow band near the top of your browser window, which will let you know if you need to disable the blocker and how to do it.

ALERT: You may need to restart your computer after you finish installing the software – you will be prompted to do this.

2 Perform a simple scan

Clean your scanner 31

Clean your printed photo 32

Start your scanner 33

Place the photo appropriately 34

Preview your scan on a flatbed scanner 35

Perform a quick scan with a flatbed scanner 36

Use Windows Fax and Scan 37

Connect your standalone scanner to your computer 38

Perform a quick scan with a standalone scanner and computer 39

Save your scan 40

Understand file formats 41

Introduction

After you install your scanner software and connect your scanner to your computer, you are nearly ready to perform your first simple scan. Ideally, you have already spent some time familiarising yourself with your scanner features and software. There are a few simple maintenance steps to take first to ensure the best scan possible. This chapter will focus on scanning prints with a flatbed scanner and also a standalone, portable scanner.

Note that the scanners featured in this chapter are the Epson Perfection V330 as well as the Pandigital scanner. What you see when you scan may be different from what you see here.

Clean your scanner

Tiny particles of dust, dirt and fingerprints can show up on your scan – even more so when you are doing high-resolution scans. Start with a clean scanner as this improves your image quality and prolongs the life of your scanner.

- Avoid using common household cleaners.
- Use a computer monitor wipe or other soft, anti-static wipe.
- Avoid touching the glass whilst cleaning.
- Check if the manufacturer recommends a cleaning product (otherwise, stick with the steps above).

ALERT: Even window cleaners can leave residue on your scanner's glass which will affect the quality of the scan.

 HOT TIP: If you have a flatbed scanner, leave the cover closed when not using it to protect the glass from debris.

ALERT: If you are using a standalone or sheet-fed scanner, use a sleeve to protect the scanner and photo during the scanning process. The protective sheet is usually included in the original box.

Clean your printed photo

If your photos have been carefully stored into boxes or albums, you may only need to do a cursory check for dust, fingerprints or other problems. However, if you have been a little careless with storing your prints, take time now before you start scanning to clean them.

- Remove dirt and dust particles.
- Use a soft towel to wipe fingerprints and smooth out any creases.
- Do not remove tape from the photo.
- Do not try to repair tears.

 HOT TIP: You can use a very soft paint brush to remove surface dust and dirt from your photographs.

 ALERT: Removing tape can cause permanent damage to your print. There are editing options that can help to digitally repair these problems which will be explored later in the book.

HOT TIP: You can use an eyeglass cleaning cloth to wipe debris from the photo.

Start your scanner

Most scanners need a few minutes to warm up, so turn on your scanner well before you intend to start a scanning project.

1 Find and press the On button.

2 Wait while the scanner initialises (usually indicated by a flashing light).

3 When the light is on, your scanner is ready to work.

 Light and Buttons

Light

Buttons

The scanner has four buttons for scanning operations. The Status light indicates whether the scanner is operating normally.

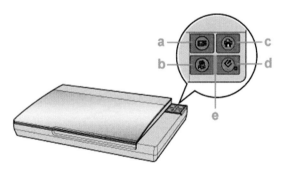

 Note:

The illustration in this section is for the Perfection V330 Photo, but the descriptions also apply to the Perfection V33.

a. ✉ Scan to E-mail button
b. 📄 Scan to PDF button
c. 🖨 Copy button
d. ⏻ Power/✎ Start button
e. Status light

 ALERT: Take time to learn about your scanner and its parts prior to starting your first scan – most basic information should be included in your getting started guide that comes with the scanner and box.

HOT TIP: If you didn't download a manual at the same time as your software, you can often find scanner manuals on the Internet at the company's website or by doing a search for your scanner model and manual or guide.

Place the photo appropriately

Most scanners include a marked corner near the edge of the glass where you should place your print.

1. Open your flatbed scanner and look for a marked corner or edge.

2. Check the orientation of the photo (landscape, etc.).

3. Align the photo with the marked corner or edge of the scanner.

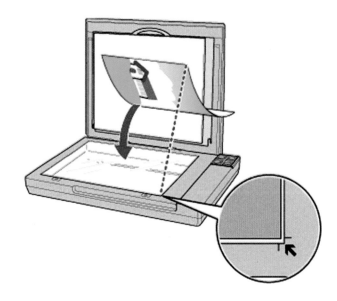

ALERT: If you have a standalone or sheet-fed scanner and decide to use the sleeve, make sure the photo is aligned correctly within the sleeve before feeding it through the scanner.

ALERT: Never place heavy objects on the glass or put too much pressure on the glass as it can permanently damage the scanner.

Preview your scan on a flatbed scanner

Some scanners automatically offer a preview of your scan before performing a complete scan. You may have to select preview early in the scanning process if your scanner does not offer this option automatically.

1 Start Epson Scan software.

2 Check you are in Home Mode.

3 Select Photograph under document type.

4 Place your print in the scanner and click Preview.

5 Check the orientation of your scan.

6 You can close the preview window or click Scan to continue.

ALERT: Your preview will most often appear as a thumbnail, or small version of your scan.

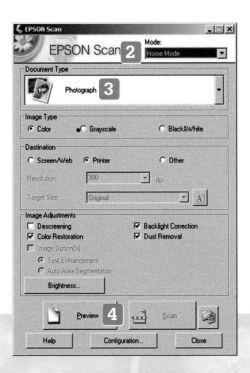

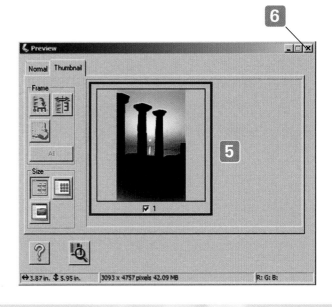

Perform a quick scan with a flatbed scanner

You can perform your first scan quickly with the automatic or default settings of your scanner software.

1 Start Epson Scan software.

2 Select Full Auto Mode.

3 Place your print on the scanner.

4 Click Scan.

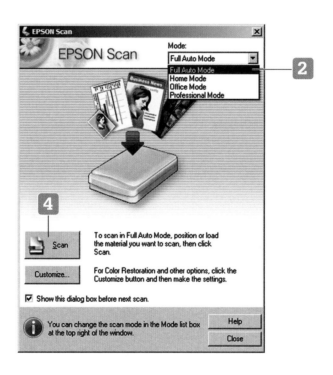

HOT TIP: Many scanners also have a one-touch option (a button physically on the scanner) and you can choose to start your scan with that button rather than launching the software.

? DID YOU KNOW?

The one-touch option on your scanner will launch your software, assess the image type and size, and adjust the colour settings for that photograph – all without you having to do anything.

Use Windows Fax and Scan

Many Microsoft Windows computers come with scanner software built in. In Windows 7, that software is called Windows Fax and Scan. You can try it to see if you prefer it over your own scanner software.

1 Connect your scanner and turn it on.

2 In the Start Search window, type Scan.

3 From the results, click Scan a document or picture.

4 Click New Scan.

5 Click Preview.

6 Click Scan.

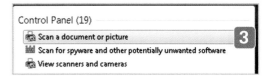

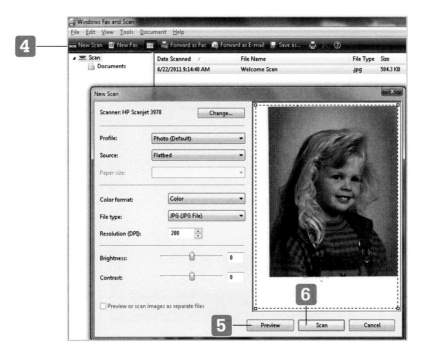

! ALERT: You must have your scanner connected and turned on for Windows Fax and Scan to work properly.

? DID YOU KNOW?
You may find built-in scanner software on your own computer, even if it isn't Windows 7. Perform a search for 'Scan' to find out.

Connect your standalone scanner to your computer

You can opt to connect your standalone device to your computer and view the files as you scan them.

1 Connect the device to your computer according to your Quick Start guide.

2 Check that a memory card is inserted in the scanner.

3 Check the scanner is plugged in and click the On button.

4 Select Open folder to view files using Windows Explorer option when the Autoplay box appears.

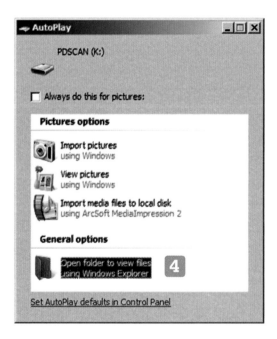

ALERT: Your standalone scanner will be viewed by your computer as a removable disk.

Perform a quick scan with a standalone scanner and computer

Perform the same steps as you would if you were to scan on a flatbed, including ensuring the photo is free from dust and other debris.

1 Check your memory card is inserted in the scanner and turn your scanner on.

2 Place your print in the protective sleeve if necessary.

3 Line up the print or the sleeve on the correct side of the scanner.

4 Select a dpi to scan at (if your scanner offers it).

5 Feed the print or the sleeve through the scanner.

6 Preview your images on your PC.

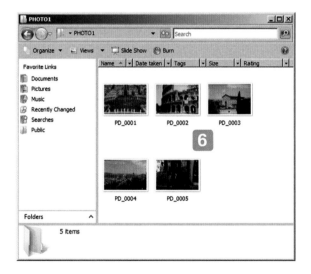

HOT TIP: If you have an old or slightly warped print, use the protective sleeve.

HOT TIP: If you want to save the images to your computer you must select Save As, name the file and select a folder on your computer for them to go to.

ALERT: Check the manufacturer's instructions for the correct way to insert the sleeve into your device.

DID YOU KNOW?

If you are not connected to a computer, follow the same steps. You can remove your memory card once you have finished scanning and view and save the images on your computer.

Save your scan

If you did not select the file settings for your scan it will most probably be saved in My Pictures or Pictures on your computer. You can also save a scanned image to a folder of your choice.

1 Click Scan while in your scanner software.

2 Select a file location (Documents, Pictures).

3 Alternatively, click Other, then browse to choose a different folder or create a new folder.

4 Click OK.

5 Click OK to scan.

6 Once the scan is complete, open the folder where you saved the scan.

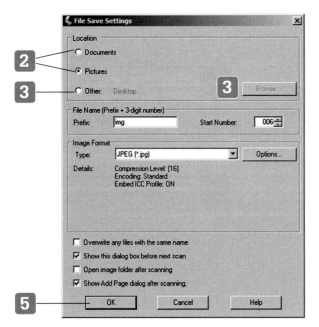

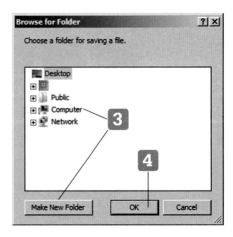

! **ALERT:** Check that you are not in auto mode or your image will be automatically saved to the default location.

! **ALERT:** Always keep a master copy of your scan and edit subsequent copies.

Understand file formats

There are several different file formats you can save your scans in. The two most common are JPEG (.jpg) and TIFF (.tif). Most of the time, your images will be automatically saved as JPEGs but there are circumstances when you will want to save a file as a TIFF.

1 Use JPEG for printing images, sending images via email and web use.

2 Use TIFF when you have a special editing project (such as an enlargement) or when you have a high-quality image that you want to preserve.

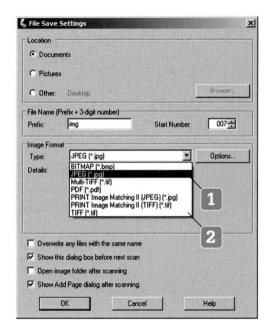

! ALERT: TIFF file format creates much larger files than JPEG.

🔥 HOT TIP: If space is a concern on your computer, save the image as a JPEG.

! ALERT: Some of the data in the image is lost, or compressed, each time you save it as a JPEG file.

3 Adjust scan results using your scanner

Preview your image 45

Apply dust removal 47

Apply Color Restoration 48

Fix backlighting 49

Adjust brightness and contrast 50

Adjust image resolution 51

Enlarge your image 52

Change the orientation of the image 53

Introduction

You can resolve several common image problems with your scanner – even before you press the scan button. Whether you choose to have the results adjusted automatically or want to select each adjustment yourself, most scanners offer options for addressing problems with lighting, colour, size and orientation.

Throughout this chapter the examples are from the Epson V330 photo scanner and ArcSoft Media Impression software which comes bundled with the scanner.

Preview your image

You can get an idea of what adjustments can be made with your scanner by starting each scan with a preview. Most scanner software offers some preview options and good software allows you to see the changes to your image before you scan.

1 Place your photo on the scanner and start the software.

2 Check you are in Home Mode in Epson Scan.

3 Select Photograph under document type.

4 Select Image Type (Color, Grayscale, Black & White).

5 Click Preview.

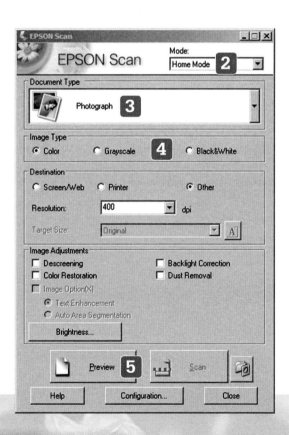

ALERT: Most software is set to default to colour images. If you are scanning a black and white photo or a grayscale photo, you must select those image types before your preview.

6 Assess the image on screen, looking for the following types of issues:

 a Too dark (underexposed).

 b Too light (overexposed).

 c Poor colour saturation.

 d Dust embedded on the image.

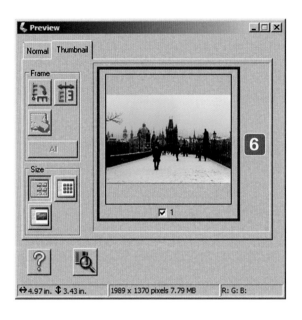

Apply dust removal

When you preview your image you may notice that dust has stuck to the image. You can have the scanner digitally remove the dust from the image while you scan.

1 Start Epson Scan software.

2 Place your photo on the scanner.

3 Select Dust Removal.

4 Click Preview.

5 Click Scan if you are happy with the preview.

ALERT: If you are using Epson Scan software and are in Auto Mode, select Customize to choose the dust removal option.

ALERT: Do not apply dust removal to an image that does not have dust on it; doing so could blur the image.

Apply Color Restoration

Many scanner software programs adjust the colour of your faded images automatically. With Epson Scan software, you must be in Home Mode or Professional Mode to apply this option yourself.

1 Preview the image you want to scan.

2 Click Color Restoration.

3 Click Scan if you are happy with the colour adjustment.

The images below show the before and after versions using Color Restoration.

! ALERT: This function only works on images with faded colours. Applying this to pictures that are not faded may result in a scan with abnormal colour.

! ALERT: Your scanner's software may have a different term for this feature. Look for terms like colour fix, restore faded colour or colour adjustment.

Fix backlighting

Backlit photos have an excess of background light which can make the details in the foreground difficult to see. This can happen when you shoot a photo while facing into the sun or any time the source of light behind the subject is greater than the light on the subject.

1 Place your photo on the scanner and start the software.

2 Click Preview.

3 Select Backlight Correction.

4 Click Scan if you are happy with the adjustment.

The images below show the before and after versions using Backlight Correction.

SEE ALSO: If you opt to use the backlight correction function, you may not need to adjust the brightness and contrast of your image. See the next section for information on this.

ALERT: Check you are in Home Mode for Epson Scan software.

HOT TIP: This feature also works well on black and white photos.

Adjust brightness and contrast

There is no hard and fast rule about when to adjust either the brightness or contrast of your image – it is a matter of personal preference. You can adjust each value independently; adjusting brightness does not affect the contrast of the image.

1 Place your photo on the scanner and start the software.

2 Click Preview.

3 Click the Brightness tab.

4 Click and drag the scroll bars to the right to increase brightness or contrast; and to the left to decrease these values.

5 Click Reset if you want to change the brightness and contrast back to the original preview.

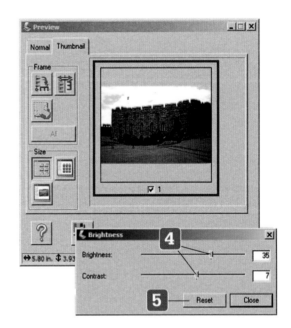

? DID YOU KNOW?
Brightening very dark originals rarely adds more detail to an image.

WHAT DOES THIS MEAN?
Contrast: this simply refers to the difference between the light parts of the photo and the dark parts of the photo.

 HOT TIP: Check you are happy with the results by watching the effect of the adjustment in your preview window.

Adjust image resolution

One useful feature of most scanning software is the ability to adjust image resolution. Images with lower resolution are best for electronic use. Alternatively, you need a resolution of 300 dpi or more if you plan to print out your images. You can adjust the dpi while scanning so that your finished scan is the resolution you want.

1 Place your photo on the scanner and start the software.

2 Under Destination, select Other.

3 Select a resolution to scan at (e.g. 600 dpi).

4 Click Preview.

5 Click Scan.

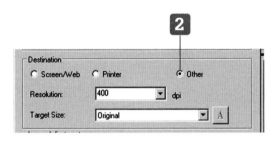

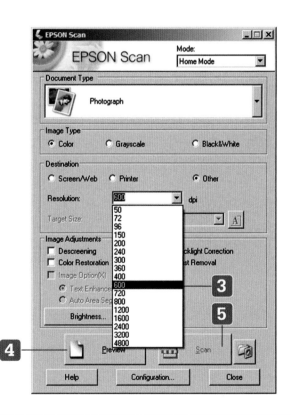

? DID YOU KNOW?
This feature may be located in the settings file or advanced picture settings of your software.

! ALERT: If you have a standalone scanner you can select the image resolution you want by pressing the correct external button.

🔥 HOT TIP: Some scanner software allows you to select a destination (print, web, etc.) for your image, and automatically suggests a resolution to scan at.

? DID YOU KNOW?
You *can't* improve a low resolution image by scanning it at a higher dpi.

Enlarge your image

You can scan your original 4 × 6 print (or any sized original) and tell the scanner to create a larger copy for printing or use on your computer.

1 Preview the image you want to scan.

2 Click on the Target Size bar.

3 Select a size to scan at (e.g. 5 × 7).

4 Increase the resolution (dpi) to at least double.

5 Click Preview.

6 Click Scan if you are happy with the preview.

ALERT: You must preview the image first or the option of changing the target size will not be offered in Epson Scan.

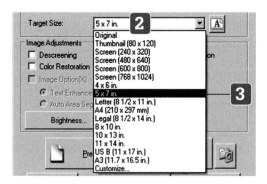

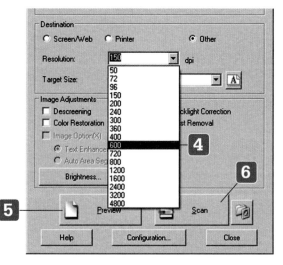

ALERT: Part of your image may be cropped slightly to make the change. You can see what will be trimmed by looking at the dotted frame (marquee) in the preview screen.

HOT TIP: You should double the dpi each time you double the output size of your image (e.g. from 4 × 6 to 8 × 10), particularly if you plan to print the image.

Change the orientation of the image

You can alter the orientation of the image (from landscape to portrait, for example) while using the target size tool.

1 Preview the image you want to scan.

2 Select a target size (e.g. 8 × 10).

3 Click the image to the right of the Target Size to change the orientation.

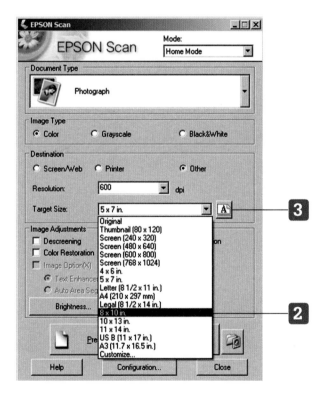

ALERT: Target size refers to the size of the image you want to create, not the existing size of your photo.

4 Check that you are happy with the results in the preview screen. (Here an image has been changed from landscape to portrait.)

5 Click Scan.

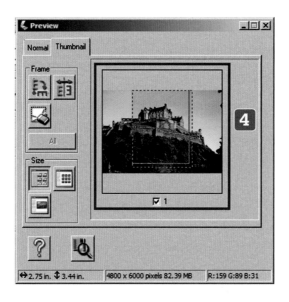

ALERT: Some of the image may be trimmed when the orientation is altered. This is shown by the dotted frame in the preview window.

HOT TIP: You can choose what part of the image to trim by clicking and dragging the dotted frame around the preview screen.

4 Adjust results with editing software

Open your scanned image in editing software	57
Use automatic adjustments	59
Rotate your image	60
Crop your scanned image	62
Straighten your image	63
Remove red-eye	64
Repair torn or blemished images with the clone tool	65
Adjust brightness and contrast	67
Adjust colour saturation	68
Increase the size of your image	69
Frame your scanned image	70

Introduction

While you can perform some of the same tasks with editing software that you can with your scanner, editing software gives you more control over the results and you can fix more complex problems than with a scanner alone. Experimenting with editing software is also a lot of fun and there are many options to choose from, including using the software that came with your scanner, and using Windows Photo Gallery as well as the free and low-cost options available to download. ArcSoft MediaImpression 2, which comes bundled with the Epson Perfection V330 Scanner and the free IrfanView software, is used in this chapter.

Note that Chapter 1 has details of how to download IrfanView.

Open your scanned image in editing software

To begin editing you need to open an image while in your software program. Your software program may have more or fewer steps for opening an image than what is shown here.

1 Start the editing software.

2 Click on Pictures.

3 Scroll through the folders to find the scanned image you want to edit.

4 Click once on the image you want to edit.

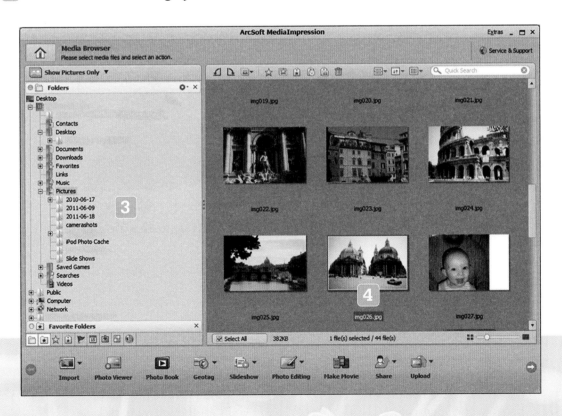

5 Point your cursor to the Photo Editing tab.

6 Select Photo Editing Tools.

7 View the image as it opens in the editing software.

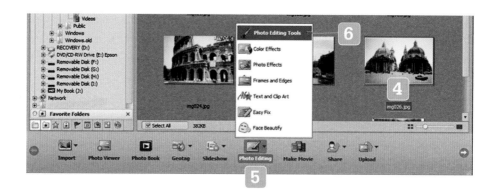

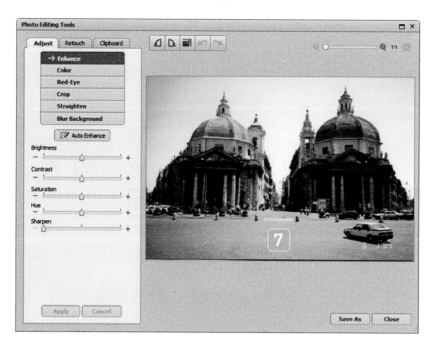

? DID YOU KNOW?

In some software programs, you start the software, click file and then open an image you want to work on.

Use automatic adjustments

If you have a large number of scans to edit, you may not have the time to work on each one in any depth. There are good automatic fixes that will enhance your scanned image quickly.

1️⃣ Open your image in your editing software.

2️⃣ Click Auto Enhance.

3️⃣ Click Apply.

4️⃣ Click Save or Save As.

5️⃣ Name your file and save it in a location you will remember.

? DID YOU KNOW?

You can also make one or two quick adjustments to brightness, contrast and colour, after you apply Auto Enhance. Click and drag the scroll bars to adjust these.

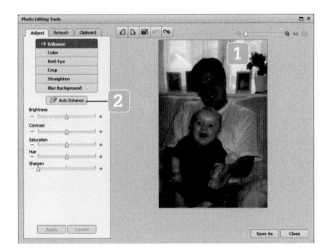

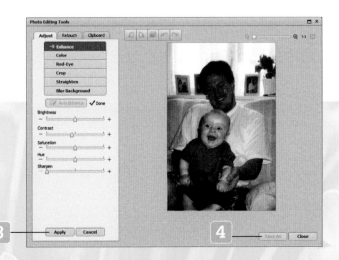

Rotate your image

You may have scanned your image in the wrong orientation or need to change the orientation for some other reason. It takes just a few clicks with most editing programs to resolve the problem.

With your image open in the editing software:

1 Click the rotate symbol.

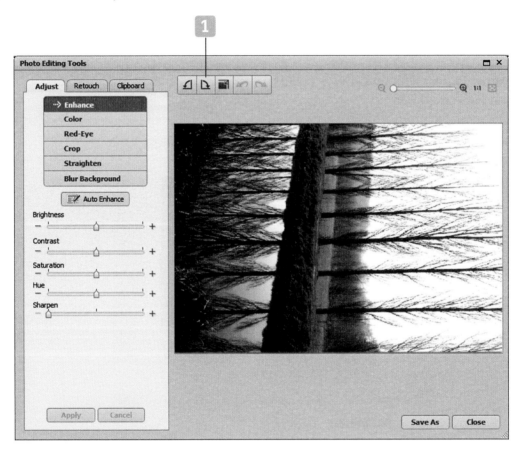

2 Click Save As.

3 Name and save your image to a file of your choice.

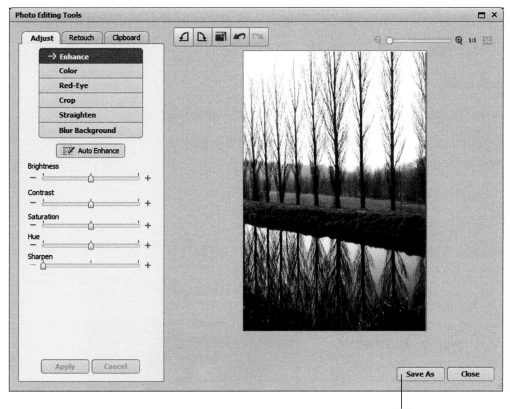

2

HOT TIP: At any point, if you want to change or undo a selection you make, click the Undo button .

Crop your scanned image

You may want to focus in on one part of your image, trim the edges or eliminate a problem with some part of the photo. All software programs offer a crop option and it is often one of the easiest tools to apply.

With your image open in the editing software:

1 Click Crop.

2 Move the frame around the picture to get the crop you want.

3 Click and drag the edge of the crop frame to expand or reduce the size of the crop.

4 Click Crop.

5 Click Save As.

6 Name and save your image.

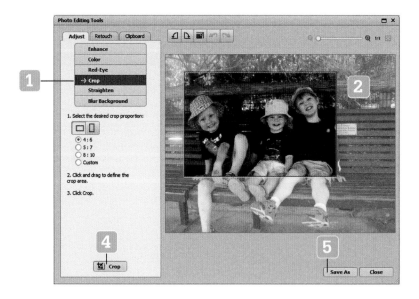

Straighten your image

Even if your scanner automatically adjusts imperfectly placed photos in the scanner, you may still have a problem to address if the original image was crooked.

With your image open in the editing software:

1 Click Straighten.

2 Click and drag on the scroll bar to adjust the image.

3 Click Apply.

4 Click Save As.

5 Name and save your image to a file of your choice.

HOT TIP: Find a straight edge in your image (e.g. a wall or steps) and align that with the grid lines in the editing tool.

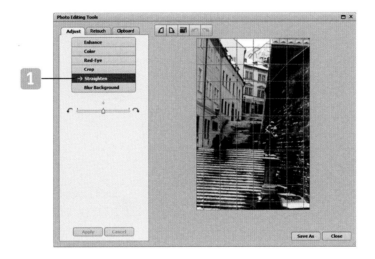

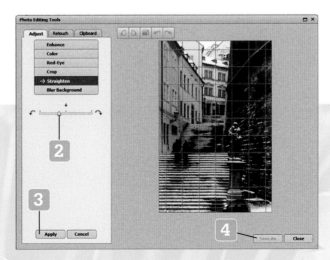

Remove red-eye

Red-eye occurs with annoying frequency for the average photographer. While there are steps to take to avoid red-eye problems, all editing software offers red-eye fix problems that take only seconds to apply.

With your image open in the editing software:

1 Click Red-Eye.

2 Click Fix Red-Eye.

3 Click Save As.

4 Name and save your image to a file of your choice.

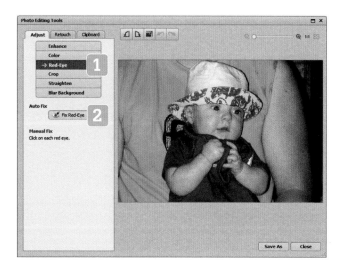

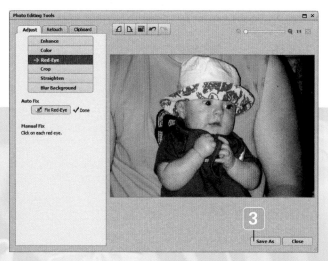

? DID YOU KNOW?

In Windows Photo Gallery click on Fix and a repairs tool bar will appear to the right. Click the Fix Red-Eye tool then click and drag your cursor to each eye to adjust.

Repair torn or blemished images with the clone tool

If your photo is torn, bent or has one of those annoying date stamps in the corner, you can often correct these using the clone tool. The clone tool simply copies a small sample of unblemished image and paints that sample over the area containing the marks or blemishes.

With your image open in the editing software:

1 Click the Retouch tab.

2 Click on the Clone tool.

3 Shift-click to clone an area of the image.

4 Adjust the size of your clone area by changing the size of the brush.

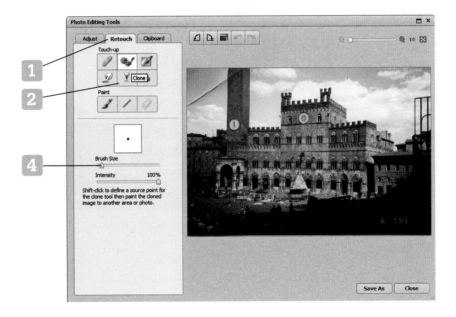

5 Click on the zoom scroll bar at the top to focus in on the area.

6 Click your mouse over the area that needs repair.

7 Click Save As and name your repaired image.

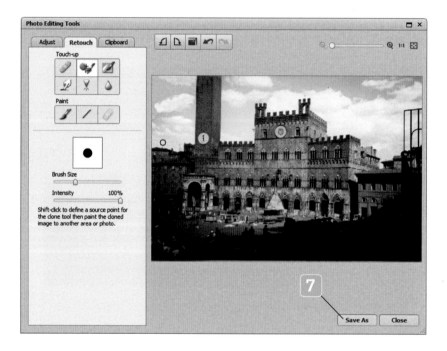

Adjust brightness and contrast

You can experiment with adjustments to your photos, especially when the software comes with a preview screen where you can see the effects of your editing while you work. IrfanView was used to edit the photos in the next four sections.

1 Double-click to launch the software.

2 Select File and Open to find the image you want to edit.

3 Click Image from the menu bar and select Color corrections.

4 Click and drag the scroll bars to adjust the brightness and contrast.

5 Click Apply to original.

6 Click OK.

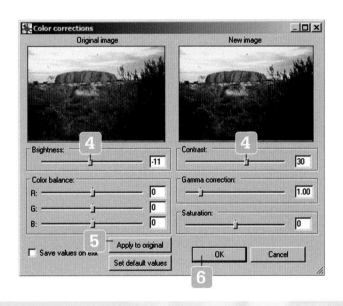

? DID YOU KNOW?

Similar adjustments can be made with Windows Photo Gallery. Open your image and click Fix at the top of the gallery and the brightness and contrast tools will appear.

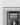

! ALERT: Save an original of your image before editing. Click the Save As button shown here to do this if you haven't already.

Adjust colour saturation

Image colours can fade over time or perhaps the photo was always a little washed out. You can improve on the original by adjusting the colour saturation. Saturation simply refers to the purity and intensity of the colour in the image. Very dull photos have low colour saturation.

1 Double-click to launch the software.

2 Select File then Open to find the image you want to edit.

3 Click Image from the menu bar and select Color corrections.

4 Click and drag on the Saturation scroll bar to adjust.

5 Click Apply to original.

6 Click OK.

Increase the size of your image

If you have a favourite photo that you want to change to a different size you can use the resize option in IrfanView. The software does a great job of automatically adjusting the image ratio for you and you can calculate the size in centimetres or inches rather than pixels.

With your image open in the software:

1 Click Image and select Resize/Resample.

2 Select the inches or cm button under Set new size.

3 Enter a value into the width or height field (e.g. 7). Enter a value into one field only (width or height).

4 Check that the Preserve aspect ratio box is ticked.

5 Click OK.

> **? DID YOU KNOW?**
> You only need to enter width or height as the software will automatically calculate the corresponding value for you to preserve the proportions of the image.

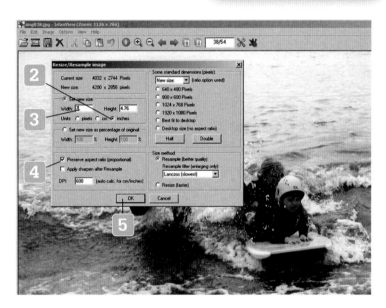

> **! ALERT:** You may have to crop part of your image when enlarging.

> **? DID YOU KNOW?**
> You can send your digital enlargements to a photo processing centre to have them printed out. Many allow you to upload your images to their website for processing.

Frame your scanned image

You can add simple frames to enhance your scanned image for use electronically or when you print them out. You can customise the style and colours of your frame for more dramatic results or use a white or plain border to act as a mat.

With your image open in Irfan View:

1 Click the Image file.

2 Select Add border/frame.

3 Click through the Frame styles and select one that you like.

4 Customise the frame colours by clicking on the Choose button next to each border (e.g. Border-1 (outer) color, Border-2 color, etc.).

5 Click OK.

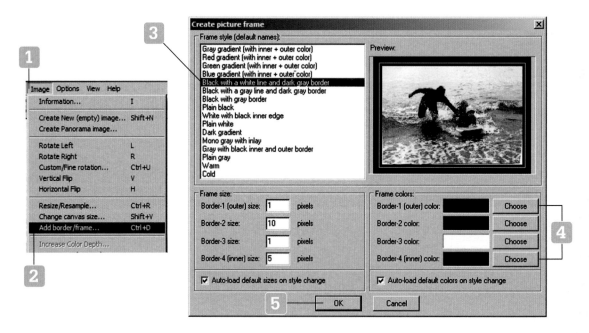

ALERT: The number of border colour options depends on the type of frame style you selected. Some frame styles only contain one border and offer only one colour option to choose.

5 Scan slides and film with an adapted flatbed scanner

Adapt your scanner 73

Place your negative film 74

Place your film holder in the scanner 75

Preview your negative scans 76

Adjust the image and scan 78

Place your slides 79

Preview your slides 80

Adjust the image and scan 81

Introduction

If you have a flatbed scanner with a transparent media adapter (TMA) you may have to either connect an attachment or adapt your scanner in some other way. The TMA is the mechanism in the scanner that focuses light through the negative or film. There are also special accessories that hold the film in place that are specific to your scanner. The examples in this chapter are from the Epson Perfection V330 and accompanying software. The first half of the chapter focuses on scanning negatives and the latter half introduces scanning slides.

Note that it is not possible to get a good scan of negatives or slides on a flatbed scanner without a TMA and the associated accessories.

Adapt your scanner

In order to scan slides and film you need to convert your flatbed scanner into a negative and film scanner. This can be done in just a few minutes with the Epson Perfection V330 following the steps below.

1. Open the scanner cover.

2. Remove the document mat by pulling it carefully upwards and out of the scanner.

3. Clean the transparency unit window.

4. Clean the document table.

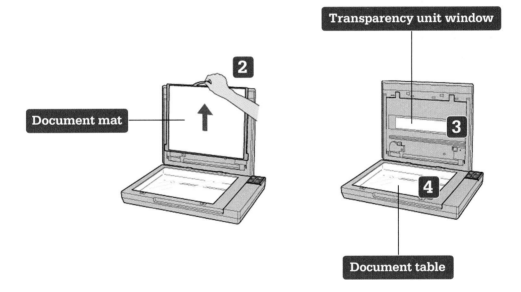

Document mat

Transparency unit window

Document table

 HOT TIP: Use a very soft cloth or anti-static wipe to clean the transparency unit and the document table.

? DID YOU KNOW?
The steps for adapting your scanner may be different from what you see here. Check the user's guide for information on your specific scanner.

Place your negative film

Pay special attention when handling your negatives as you can damage the film if you touch it directly with your fingers. You can also use either tweezers or cotton gloves to inspect and place your negative film.

1 Pick up the film by the edges.

2 Check the film is free from dust and debris.

3 Open the film strip holder.

4 Place the film with the shiny base facing down.

5 Close the film strip holder by pressing it down until it clicks.

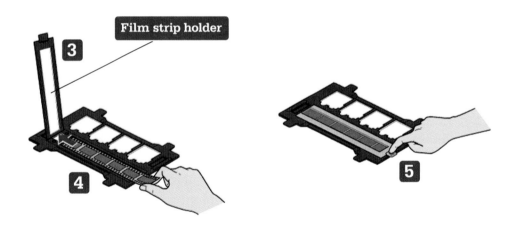

Film strip holder

3

4

5

 HOT TIP: You can use compressed air to remove dust from your strips of film.

 HOT TIP: Any numbers or wording on the film strip will appear backwards if the film is placed correctly.

Place your film holder in the scanner

Most scanners have their own system to ensure that originals are placed properly into the unit before scanning. If not placed correctly, the scanner won't work at all.

1 Locate the film icon tab on the film holder.

2 Align the icon on the film holder with the same icon on the scanner.

3 Check the film holder is placed evenly into both slots on the edge of the scanner.

4 Close the scanner lid.

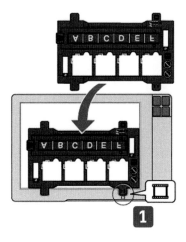

ALERT: Check one final time that your negative film is placed in the film holder correctly by comparing it with the image below.

Preview your negatives scan

Use the preview option on your scanner to check you loaded the film properly and that there are no major problems, such as scratches to the film that you may have missed.

1 Start the software.

2 Check you are in Home Mode in Epson Scan.

3 Select document type (Color Negative Film or B&W Negative Film).

4 Select destination (screen, printer, etc.).

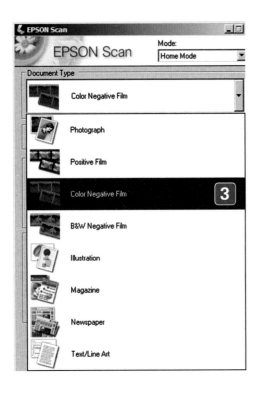

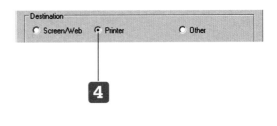

5 Click Preview.

6 If you do not want the dotted frame (marquee tool) to appear in your preview, click the erase marquee.

7 Click through the images on the preview screen

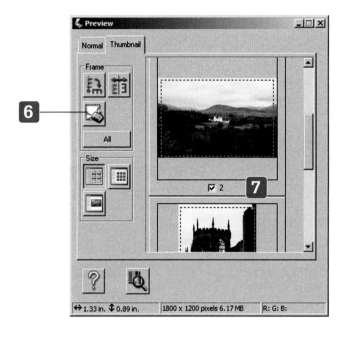

Adjust the image and scan

After you check the preview window for any corrections, you can adjust the results of your scanned negatives in the same way as you do for photographs. See Chapter 3 for a review of how to do this.

1 Select the Target Size for your scan (it will always need to be a different size as it's a small image).

2 Click Scan.

3 Choose a location to save your scan.

4 Click OK on the Browse for Folder window.

5 Click OK on the File Save Settings window.

ALERT: You must preview your image first before you can select this option.

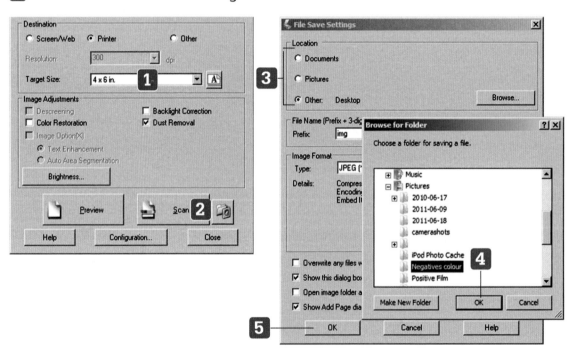

ALERT: Epson software will automatically save your scan to the last location you selected.

? DID YOU KNOW?

Scanning negatives takes longer than scanning photos or slides, the image has to be both converted and scanned.

Place your slides

Placing your slides appropriately in the film holder can be a little tricky and may take you a few tries. Start with one slide until you are confident about placing your slides in the scanner.

1 Locate the slide icon tab on the film holder.

2 Align the icon on the film holder with the same icon on the scanner.

3 Check the film holder is (placed) evenly into both slots on the edge of the scanner.

4 Check your slides are free from dust and debris.

5 Place your slide into the holder.

6 Check your slide is aligned correctly by comparing it with the image below.

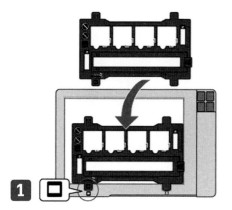

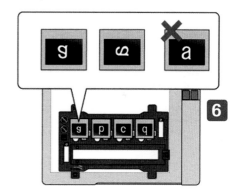

ALERT: Check the instructions for your scanner. Every TMA scans in different ways and you may need to orient your slides differently.

Preview your slides

Use the preview option to check the slides are loaded correctly and that there are no problems with the image.

1 Start the scanner software.

2 Select Positive Film under Document Type.

3 Select Image type (e.g. Color).

4 Select a destination (screen or printer).

5 Click Preview.

6 Click through the images in the Preview box.

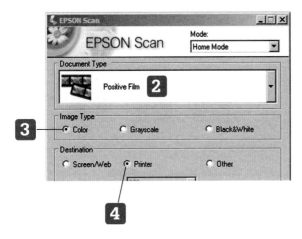

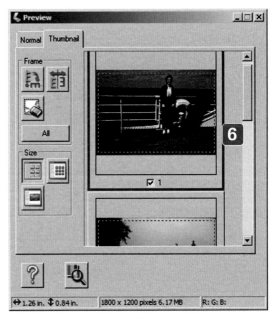

 HOT TIP: If you un-click one of the images in the preview box, it won't be scanned.

Adjust the image and scan

Once you preview your slide, you may want to make an adjustment to the image or apply dust removal to your slide before you scan.

1 Select Target Size for your image.

2 Apply Image Adjustments as necessary.

3 Click Scan.

4 Choose a location to save your scan.

5 Click OK on the Browse for Folder window.

6 Click OK on the File Save Settings window.

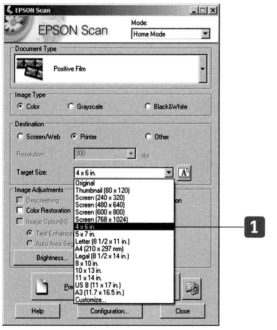

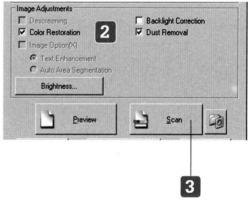

> **SEE ALSO:** Make adjustments for your scanned slide images the same way you do for photos. See Chapter 3 for a review of how to do this.

6 Scan with a dedicated film scanner

Sort your film	85
Place negatives in the film holder	86
Place the film holder in the scanner	87
Perform a prescan of your negative	88
Adjust size and resolution	90
Correct brightness, contrast and colour	92
Scan and save your negative	93
Place your slides in the film holder	94
Place the slide holder in the scanner	95
Perform a prescan of your slide	96
Adjust the slide image	97
Scan and save your slide image	98
Apply auto adjust	99
Apply dust and scratch removal	100

Introduction

If you have a very large collection of negatives and slides, you might have purchased a device that scans only those types of film. The quality of scans from these scanners tends to be better than those from an adapted flat bed and come with many features that will enhance and repair your images. The scanner featured in this chapter is the Plustek OpticFilm 7600i SE. It comes bundled with SilverFast software; a sophisticated program that is capable of fairly advanced image editing and deserving of a more thorough explanation than can be provided here. The basic tools are outlined in this chapter, as well as a few advanced features worth noting.

Sort your film

Grouping your film by type will save you time when you start the scanning process, especially if you have a large amount of film to scan. SilverFast software makes automatic adjustments to your image based on the information you provide about the film type.

1 Negatives
 a Look for the manufacturer's name (e.g. Kodak, Fuji, Agfa).
 b Look for the film type and speed.

Manufacturer

2 Slides
 a Sort by colour or black and white.
 b Group Kodachrome slides together.

 ALERT: You will need this information prior to starting your scans with SilverFast and other scanning programs.

HOT TIP: Look at the top of the film strip for manufacturer information and type.

Place negatives in the film holder

The method for placing negatives into film holders varies by scanner and the instructions below are specific to the Plustek device. Always hold negative film by the edges as they are prone to scratches and damage from handling.

1 Open the film holder.

2 Check your image is the right-side up. Any writing or numbers on your negative should appear correctly oriented.

3 Carefully place the film in the holder.

4 Close the film holder until you hear a click.

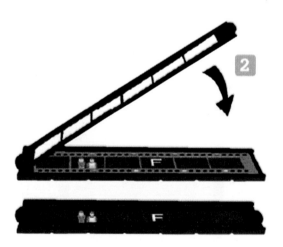

ALERT: Make sure you know what sort of film type it is *before* closing it in the film holder; you will be prompted by the software to select the type of film.

? DID YOU KNOW?
The Plustek film holder can secure a negative film strip of up to six frames.

Place the film holder in the scanner

The film holder for the Plustek scanner advances by manually pushing it through the scanner. You must advance the holder carefully through the scanner and scan one image at a time.

1. Orient the film holder so that the top of the image is facing the back of the scanner.

2. Check you can see the wording on the top of the film holder.

3. Gently place the film holder into the scanner.

4. Check that you can feel the holder click through each indexed position as you push it through the scanner.

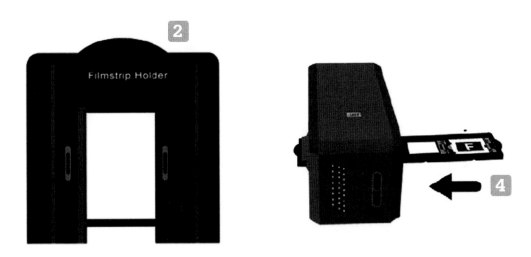

Filmstrip Holder

ALERT: Move the film holder through the scanner gently, it should move through each of the indexed positions easily.

Perform a prescan of your negative

The prescan option in SilverFast is similar to the preview option in other software programs. It allows you to check that your image is placed correctly and that you are scanning the image you intend to.

1 Double-click to start SilverFast.

2 Click the SilverFast tab.

3 Select Basic mode.

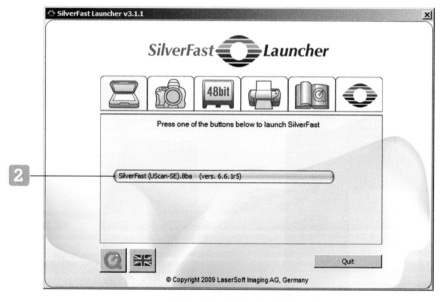

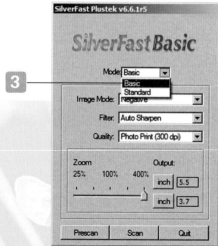

4 Select Negative, in Image Mode.

5 Select the film manufacturer, type and speed when the dialogue box appears.

6 Click Prescan.

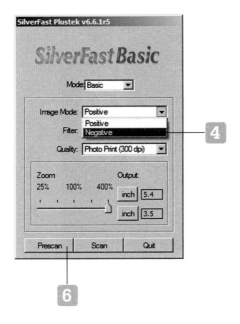

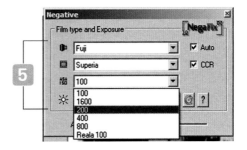

ALERT: Change the negative film selection each time you scan a new type of negative. The software will automatically save the last settings you selected.

DID YOU KNOW? The software will automatically make adjustments to your image based on the type of negative you select.

Adjust size and resolution

After you prescan your negative you need to tell the scanner what size and resolution to scan at. You can apply the same adjustments to your slide images as well as your negatives.

With your image in prescan view:

1 Click and drag the frame (marquee tool) to select the area you want to scan.

2 Click on the rotate tool if you need to change the orientation.

3 Click Quality and select a resolution to scan at.

4 Adjust the output size by clicking and dragging on the zoom bar. You can click on the box next to zoom bar to switch from inches to centimetres.

ALERT: 300 dpi is good for printing or archiving your image but if you are using the image electronically only, you can select a lower resolution.

Correct brightness, contrast and colour saturation

In the Basic Mode of SilverFast you can apply several quick adjustments to your image by manipulating the scroll bars in the Picture Settings box. You can use these adjustments for your slides as well as your negatives.

With your image in prescan:

1 Click and drag on the brightness scroll bar to increase or decrease brightness.

2 Watch for the results of your modification in the Prescan window.

3 Click the Reset button if you are not happy with your changes.

4 Click and drag on the contrast and saturation scroll bars to adjust those.

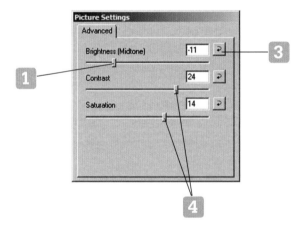

ALERT: You can't increase the detail of a very dark original by increasing brightness.

Scan and save your negative

Before you click Scan consider what you want to do with your image. If you want to print it out or save it in a digital archive, you can save it as a JPEG file. If you want to do lots of editing to the image, you may want to save it as a TIFF file.

1 Click Scan.

2 Select a folder to save your scan.

3 Name your file.

4 Select a file format (JPEG or TIFF).

5 Click Save and wait while your image scans.

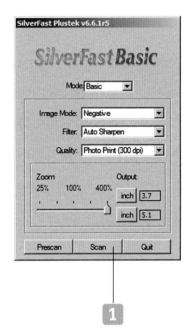

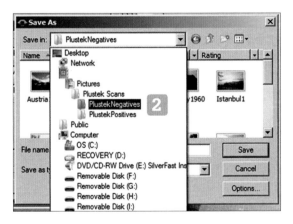

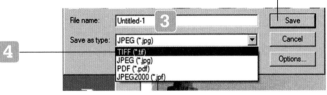

! ALERT: Remember that TIFF files take up a lot of your computer's resources. Only use TIFF if you need to spend a lot of time editing the image.

? DID YOU KNOW?
Each time you open and save a JPEG file, some of the image information is lost.

Place your slides in the film holder

There is a different holder for slides that you must use while scanning. Placing your slides correctly can involve some trial and error. Look for slides that have words or numbers in them to check the orientation of your image.

1 Check your image is right-side up.

2 Look for the embossed image on the slide.

3 Place the embossed side face down in the holder.

4 Push the slide in the holder until it snaps into place.

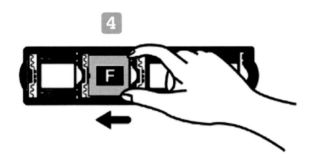

WHAT DOES THIS MEAN?
Embossing: the layers of colours that make up the image.

! **ALERT:** Your scanner may have different requirements for placing slides appropriately, check your user guide for information on this.

Place the slide holder in the scanner

The holder will secure up to four of your slides. Check that all are positioned correctly and are free from dust and debris before you place them in the scanner.

1 Hold the film holder with the top of the image facing the back of the scanner.

2 Insert the holder with the words facing up.

3 Insert the film holder into the scanner.

4 Stop pushing when you feel the first indexed position on the holder connect with the scanner.

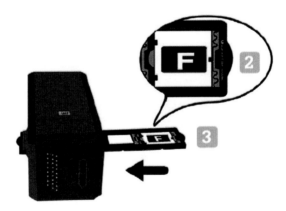

 HOT TIP: You can feel the indexed positions if you push and then pull back the holder.

Perform a prescan of your slide

Always start a scan of your slides with a prescan and use it to check the position and orientation of your slide in the scanner and that you are scanning the slide you intend to.

1 Start SilverFast software.

2 Check you are in Basic Mode.

3 Click on Image mode and select Positive.

4 Click Prescan.

5 Check your image is oriented correctly.

6 Realign your slides if necessary or correct any placement problems.

Version Upgrade: SilverFast scanner software is now available in completely revised version 8 including the unique WorkflowPilot – a kind of wizard guiding the user step-by-step. For more information, please visit www.SilverFast.com.

HOT TIP: If the image contains any words or numbers, check that they are in the correct direction.

Adjust the slide image

Once you have a preview image on the screen to work with, make adjustments as needed to the scan area, orientation and output size of your image.

1 Click and drag the frame to select the area you want to scan.

2 Select a dpi to scan at by clicking on Quality.

3 Select the output size by clicking and dragging the zoom bar.

4 Click on the tabs next to the zoom bar to switch between inches or centimetres.

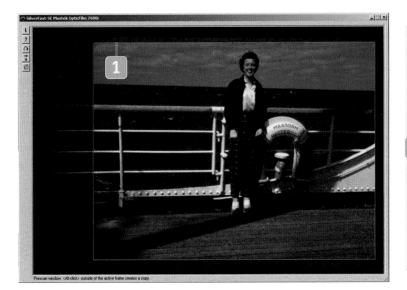

ALERT: If you cropped the image at all, you may have a limited choice in output size.

? DID YOU KNOW?

You can adjust the brightness, contrast and colour saturation of your image by clicking and dragging on the bars in the Picture Settings window. See the 'Adjust size and resolution' for more on how to do this.

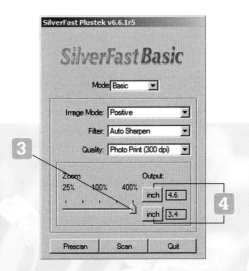

Scan and save your slide image

Once you have made the adjustments to your image, you are ready to scan your slide. Consider how you will use your slide image before you save it. See the earlier section 'Scan and save your negative' for more information on this.

1 Click Scan.

2 Click on the drop-down menu next to select a folder.

3 Name your file.

4 Save as a TIFF or JPEG.

5 Click Save.

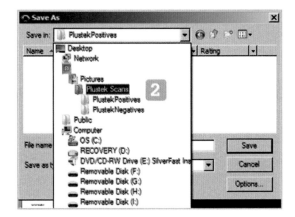

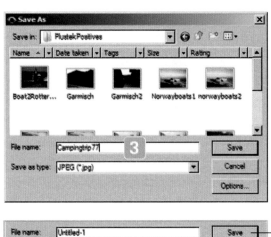

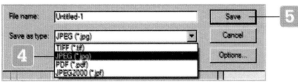

ALERT: Cover your scanner and holder when not in use to keep them free from dust and debris.

Apply auto adjust

In order to use the auto adjust feature in Silver Fast, you need to switch to Standard Mode. This mode has excellent automated enhancement and repair options and makes adjustments based on the type of image you are scanning.

1. Select Standard Mode in Silver Fast.

2. Click the General tab and select the type of film (e.g. Kodachrome).

3. Click Prescan.

4. Click the Frame tab and select image type (e.g. Landscape).

5. Click Scan, and name and save your file.

! ALERT: Your image will be automatically adjusted after you select the image type. Watch for the changes in the prescan window.

? DID YOU KNOW?

This program and others like it offer a special option for scanning Kodachrome slides. These slides can have a predominant blue cast which will be automatically fixed while scanning.

Apply dust and scratch removal

Negatives and slides are particularly prone to damage from scratches and attract dust if not stored properly. The damage isn't always obvious to the naked eye but will show up when you scan. SilverFast has an excellent dust and scratch removal option that you can apply while you scan your colour negatives or slides.

1. Select Standard Mode in Silver Fast.

2. Click the General tab and select the film type.

3. Click Prescan to preview the image you want to use.

4. Click once on the iSRD icon. The icon should change from black and white to colour to show the feature is activated.

5. Click Scan, and name and save the file.

ALERT: This feature does not work well for black and white negatives.

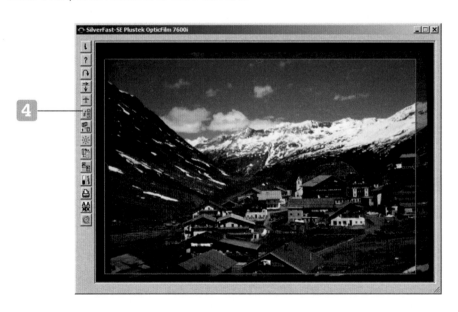

ALERT: The dust and scratch removal will take place during the scan. You can see the results after your image has been scanned and saved.

ALERT: You must change the type of film you are scanning each time you change film types. The program will use the last selections you chose.

7 Batch scan photographs and film

Sort compatible photos and film 103

Align photos on the scanner 104

Preview images 105

Rotate your batch 106

Apply adjustments to your batch 107

Set the scan area for your batch 108

Scan and save your batch 109

Preview slides or negatives for batch scan 110

Adjust your batch scan of slides 111

Select output size 112

Scan and save your batch slides 113

Introduction

If you have a large volume of photographs or film to scan, you can save time by scanning them in batches. Many flatbed scanners and even all-in-one devices allow you to scan several images simultaneously. You can also apply adjustments to several images at once rather than adjusting each image individually. The software used in this chapter is the Epson Scan software in Professional Mode. This mode has many more advanced features but using it to batch scan images is really just a matter of a few extra clicks.

Sort compatible photos and film

Keeping similar images together will make your job of placing and editing them easier. You can make full use of your scanner bed by placing photographs of the same size together.

1 Keep images logically together – from the same roll of film or same period of time.

2 Sort by size.

3 Sort by image type (photographs, film, black and white, etc.).

? DID YOU KNOW?

Organising your photos into groups like this will also help with editing later. If a group of photos from one roll of film have similar problems, you can apply adjustments to all of the images simultaneously.

Align photos on the scanner

You can get the most out of your batch scan if you place photos of a similar size on the scanner. For example, if you have four 4 × 6 photographs, you can usually scan them all at once on most flatbed scanners.

1 Check your images are oriented the same way.

2 Place your first photo near the marked corner of the scanner bed.

3 Put your subsequent photos next to the others, allowing at least 2mm between the photos.

4 Close the scanner lid gently.

HOT TIP: If your photos are the same size and shape, they should create a gridline on the scanner bed.

ALERT: If your photos are too close together, they will scan as one image.

Preview images

If your photos were placed correctly, you will have up to four images in your preview screen after clicking preview. You can view the images individually or all at once to check they are correctly aligned and as you anticipated.

1 Select Professional Mode.

2 Select Reflective under Document Type for photographs.

3 Choose a resolution to scan at.

4 Click Preview.

5 Click the Normal tab on the preview screen to view all the images at once.

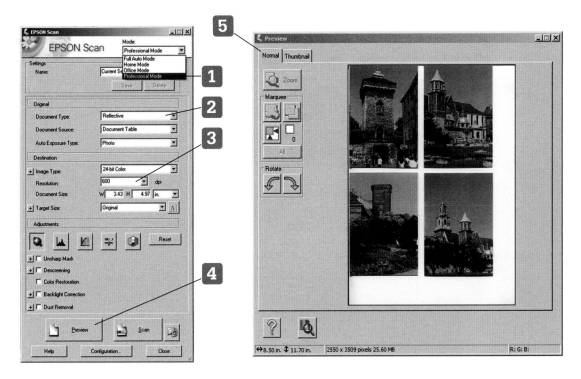

SEE ALSO: You can also scan and edit negatives and slides in batches by selecting Film under document type. See the next section for information on batch scanning film.

DID YOU KNOW?
Your scanner may have a dedicated batch scan button or feature that automatically generates a preview. Check your user guide for information on this.

Rotate your batch

If you positioned landscape photos together in your scanner, they may need to be rotated before you scan them. You can do this after scanning but the advantage of grouping images together is that you can apply changes to all of them at once.

1 Perform a preview of the images in Professional Mode.

2 Click the Normal tab on the preview screen.

3 Click the green rotate arrow to the right or left to adjust your image.

HOT TIP: You can opt to rotate them individually but you must be in Thumbnail view in the Preview box.

Apply adjustments to your batch

Once you are satisfied that your photographs are placed correctly, you can make a few quick adjustments to them while in the preview screen. Note that the adjustments will be applied to all the images simultaneously.

After previewing your scan:

1 Click the Normal tab on the preview screen.

2 Select Color Restoration.

3 Select Dust Removal if appropriate.

4 Apply Unsharp Mask if you want.

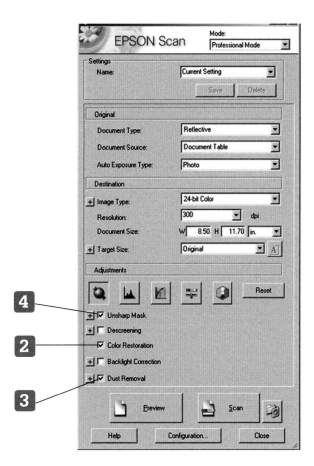

ALERT: Watch for effects of your adjustments in the preview screen – you should be able to see them immediately.

WHAT DOES THIS MEAN?

Unsharp Mask: a common adjustment in image editing programs. It enhances the contrast between the light and dark parts of the image, making the overall image appear sharper.

Set the scan area for your batch

You need to tell the scanner how much of the image you want to scan. You can also use this feature to crop any portions of the image you don't want.

After previewing your batch in Professional Mode:

1 Click Normal in the Preview screen.

2 Click and drag your cursor over each image to create a frame.

3 Repeat until you have set the scan area for all the images you want to scan.

4 Click All. You should see a dotted frame around all of your images.

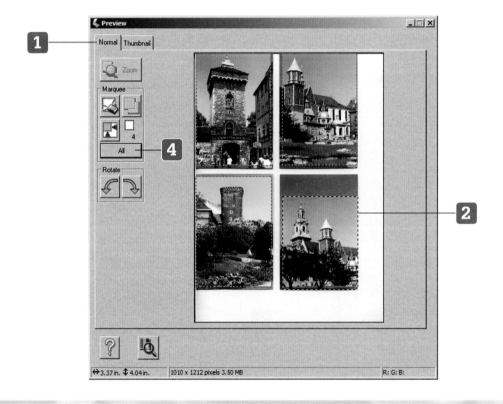

ALERT: If you don't select an area for one of the images, it won't be scanned.

ALERT: You must set the print area prior to scanning your batch. If you scan in preview mode, your images will scan as one file.

Scan and save your batch

Most software programs offer you the option of assigning a prefix to your batch file names, followed by a number. In effect, your batch will have the same name and be differentiated only by number. If you want to save each file with a unique name, you can easily rename them later in your folder.

1 Click Scan.

2 Select a location to save your images.

3 Click Browse if you want a different folder than that which appears in the Location box.

4 Name the batch in the File Name box.

5 Click on the Start Number field to select a number to start at.

6 Click OK.

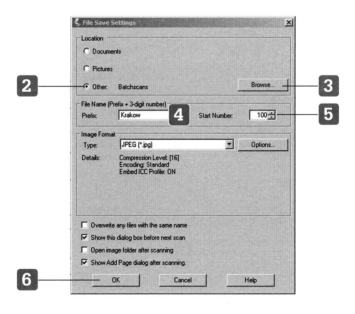

> **? DID YOU KNOW?**
>
> Your batch will be saved as four separate files (e.g. Krakow100, Krakow101, Krakow102, Krakow104).

Preview slides or negatives for batch scan

You must set up your TMA or otherwise adapt your flatbed scanner as you would to scan negatives and slides. The basic placement process is the same as scanning individually but in Professional Mode you can batch edit your slides. The example below is for slides but the same process applies equally to scanning negatives in batches.

1 Place the slides appropriately in the scanner.

2 Select Professional Mode.

3 Select Film under Document type.

4 Select Positive Film (for slides).

5 Select a resolution to scan at.

6 Click Preview.

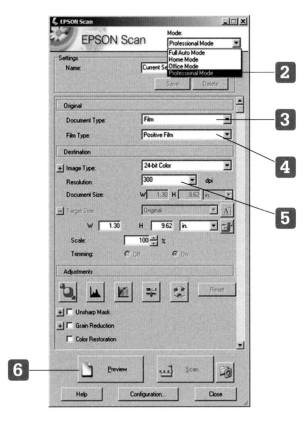

SEE ALSO: Review Chapter 5 on how to place slides in the film holder.

Adjust your batch scan of slides

You can apply needed adjustments to all of your previewed slides at the same time.

In Preview in Professional Mode:

1 Click the Thumbnail tab in the Preview window.

2 Click All in the Preview window. (The images should all have a blue frame around them after clicking All.)

3 Apply Adjustments as needed (Unsharp Mask, Color Restoration, etc.) and watch for the changes in the preview window.

4 Click the Auto Exposure button if you want.

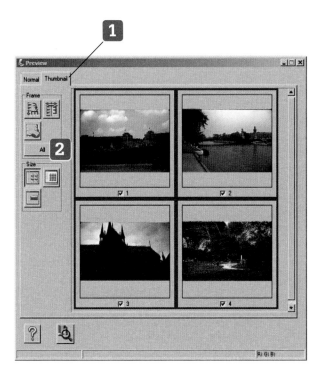

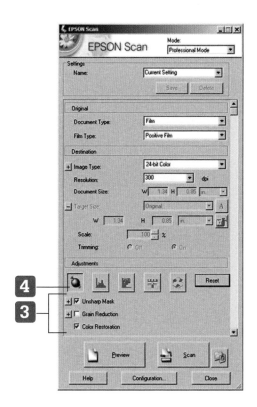

WHAT DOES THIS MEAN?

Auto Exposure: this feature automatically adjusts any exposure problems your slide image may have.

SEE ALSO: Review Chapter 5 for more information on common adjustments.

Select output size

You need to tell the scanner what size image you want after scanning otherwise your slide image will scan at its actual size. You must select the target size for each image individually but can scan them all at the same time once you do so.

1 Click on one image preview. The preview window will show the image with a blue frame around it.

2 Click on the drop-down menu next to Target Size and select the output size you want (4 × 6, 5 × 7, etc.)

3 Select the output size for the next image.

4 Continue the process until each image has a target size.

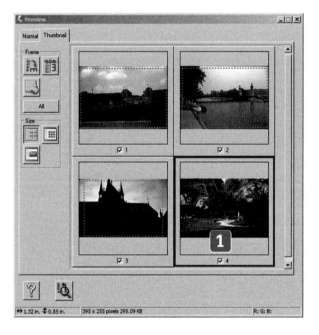

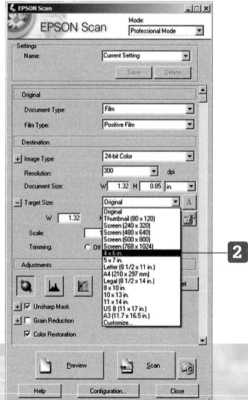

ALERT: Your image may be cropped slightly depending on the output size you select. You can see the effects of the output size by looking at the dotted frame around the image.

Scan and save your batch slides

Once you have made the adjustments you want and selected an output size for your image, you are ready to scan and save them all to a file of your choice.

1 Check all of your preview images are selected – they will have a tick beneath the image.

2 Click Scan.

3 Select a location to save to (Pictures, Other).

4 Name the batch in the File Name Prefix field.

5 Select the start number.

6 Click OK.

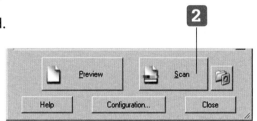

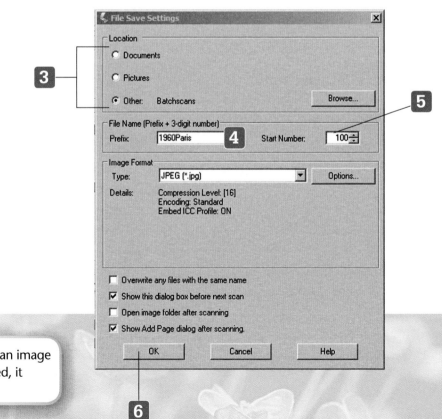

!ALERT: If an image is not selected, it won't scan.

8 Perform special scans and editing projects

Scan older grayscale photographs 117

Evaluate your image histogram 118

Adjust the histogram 120

Scan and save a file as a TIFF 122

Repair damage with the healing brush 123

Convert your image to sepia 125

Add text to your image 127

Scan a half-tone image 129

Scan an oversized image 130

Stitch and save an oversized image 132

Introduction

Special projects, like scanning and restoring old black and white photographs or scanning oversized images, can require extra effort but the results are almost always worthwhile. This chapter will explore some less common scans and editing projects you can do with your flatbed scanner and software. While the instructions are specific to the software used throughout this book, the features referred to are common to most software.

Scan older grayscale photographs

What are commonly known as black and white photos are not really black and white at all but 'grayscale'. They contain a continuous range of grey shades spanning from complete black to complete white.

1 Select Professional Mode in Epson Scan.

2 Select Reflective under Document Type.

3 Select 16-bit Grayscale.

4 Select resolution and click Preview.

5 Click the auto marquee button to set the scan area and adjust it if necessary.

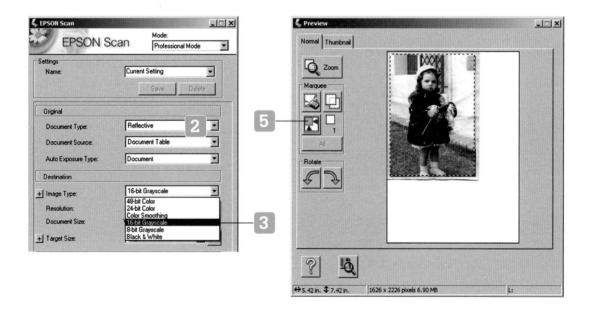

ALERT: Your photo editing program may not support 16-bit images. Check to see if it does, otherwise it will prompt you to convert the image to 8-bit before editing.

WHAT DOES THIS MEAN?

16-bit: In this case, bits refer to the range of grey shades in your image. A 16-bit grayscale image contains thousands of shades of grey. An 8-bit grayscale image contains around 256 shades of grey.

Evaluate your image histogram

A histogram is a tool for evaluating the range of shadows and highlights in an image. It is a graph of the number of pixels in each range of tone: shadows, mid-tones and highlights. The histogram can give you clues about how to adjust the tones in your image for great results, especially for older grayscale photographs.

1 Preview your image in Professional Mode in Epson Scan.

2 Select the scan area by clicking the automatic marquee tool.

3 Click on Zoom to view the details in the image.

4 Click on the histogram adjustment tool.

5 Look at your image at the same time as you assess the histogram.

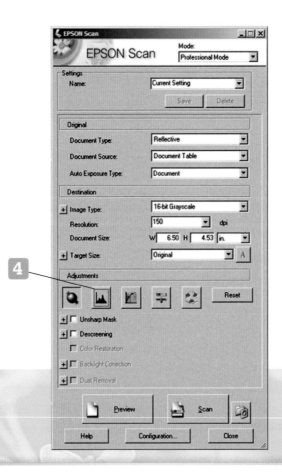

ALERT: If your image has a white frame around it, this will affect the histogram data. Select the scan area first to ensure the white frame is not included in the histogram.

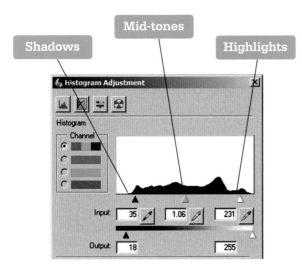

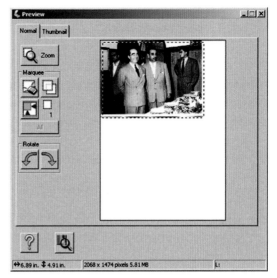

An image with good tone will have a wide distribution of shadow, mid-tones and highlights throughout the histogram. This photograph has a fairly good distribution of tone as seen in both the histogram and image.

This is an example histogram of an image where the lighter tones are almost completely absent and there are very few shadows. This image would benefit from adjustment.

 HOT TIP: If your histogram shows your image is missing shadows or highlights but you are otherwise happy with it, you may not need to adjust it.

Adjust the histogram

After evaluating the histogram data for your image and assessing the image, you can individually adjust the shadows, mid-tones and highlights to improve it. It takes a little experimentation but once you are confident with this tool, you may never go back to simply adjusting contrast and brightness.

1 Preview your image in Professional Mode in Epson Scan.

2 Click on Histogram Adjustment.

3 Click and drag the shadow and highlight sliders (black and white triangles) to the place in the histogram where the graph drops off.

4 Watch for the effect in the Preview screen.

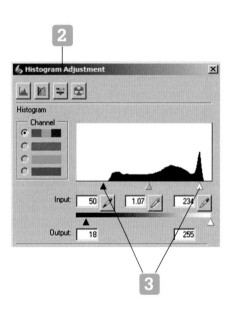

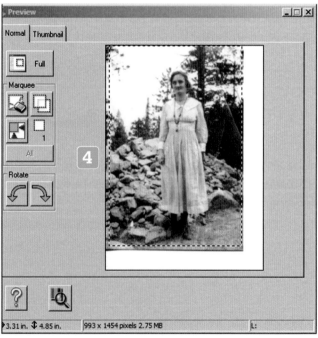

ALERT: The mid-tones will adjust proportionately when you adjust the shadows and highlights.

5 Click and drag on the mid-tone slider (grey triangle) if you want to adjust the image further.

6 If you are happy with your changes, close the Histogram Adjustment Window.

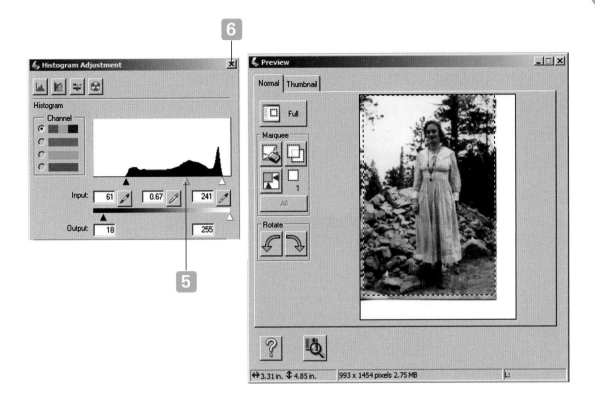

HOT TIP: You can also use these same adjustments on colour images.

Scan and save a file as a TIFF

If you have an image that will need a lot of editing, as is the case with many older photographs, consider saving it as a TIFF. It will take up more space on your computer but will prevent further image loss from compression in JPEG format.

In Epson Professional Mode:

1 Click Scan once you are satisfied with the image in Preview.

2 Select a location to save your file.

3 Name the image under File Name.

4 Select TIFF under Image Format.

5 Click OK.

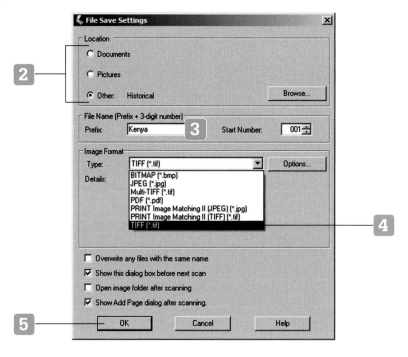

ALERT: The file will be much larger if you save it as a TIFF. If you do have limited space, consider saving only a few special images in this format.

Repair damage with the healing brush

The healing brush is similar to the clone tool but you can achieve more subtle results with it. If your photograph has a lot of damage, this can be a time-consuming repair but one that should prove rewarding. While you get the hang of the tool, you can make use of the Undo button as frequently as you need.

1 Open your image in MediaImpression.

2 Select Retouch and click on the healing brush.

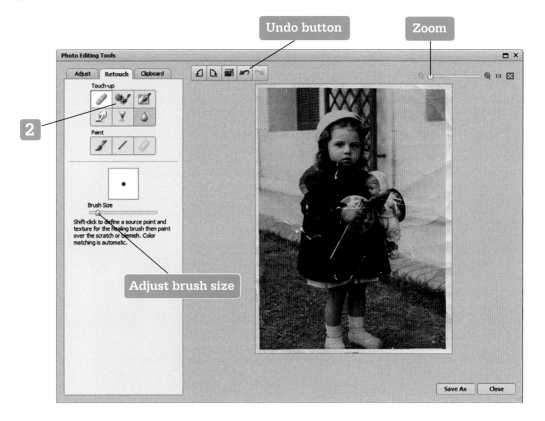

Undo button

Zoom

2

Adjust brush size

HOT TIP: Redefine the source as you work to keep the highlights and shadows in the image consistent.

3 Shift-click to copy a source to repair the damage with.

4 Zoom into an area you want to work on and click over it with the healing brush.

5 Adjust the brush size if needed by clicking and dragging on the scroll bar under the Brush Size image.

6 Click Save As when you are happy with the changes.

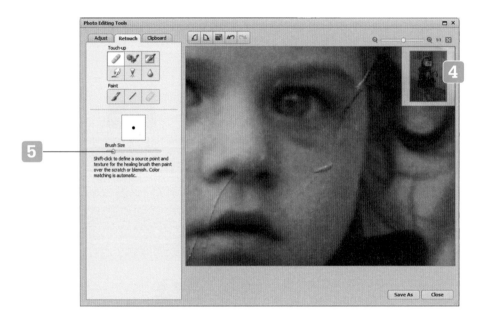

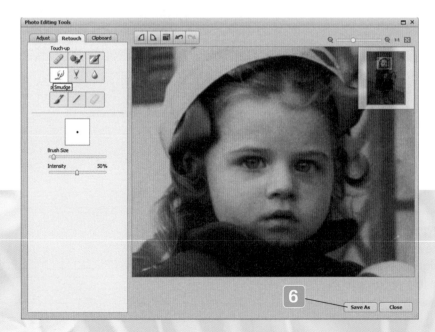

Convert your image to sepia

Sepia toned images are warmer and can provide an antique feel to your photographs. Even older, grayscale photographs may benefit from conversion to sepia. Experiment with this easy conversion tool in IrfanView – but remember to save a copy of your original before you start!

1 Start IrfanView software.

2 Select File then Open to open an image you want to convert.

3 Select Image, then select Effects.

4 Select Sepia from the Effects menu.

5 Save the image under a different file name.

ALERT: Your image will instantly convert after you choose the sepia option.

Add text to your image

Rather than writing down the date or other key information on the back of the photograph, you can add text directly to your digital image. If you have a frame around the image, this can be a good place to add a subtle text reference. The example below was done with IrfanView but many editing programs offer this feature.

1 Open your image in IrfanView.

2 Select the area you want to insert text into by left-clicking and dragging until a box appears.

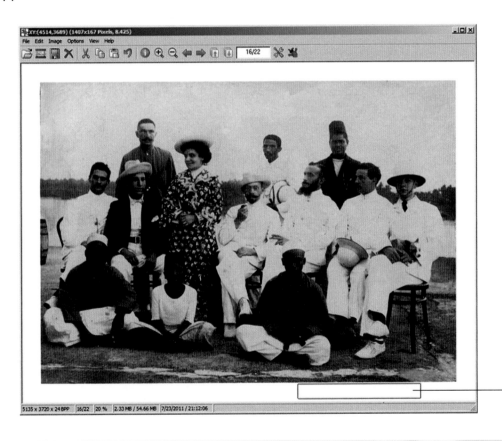

SEE ALSO: See Chapter 4 for more information on how to digitally add a frame to your image.

3 Click on Edit and select Insert text into selection.

4 Type in the text that you want in the Text box.

5 Click on the Choose Font tab to choose a font size and style and click OK.

6 Click OK in the Add overlay text to image box.

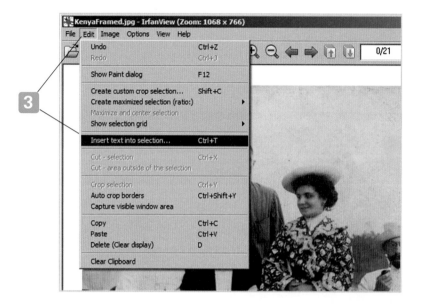

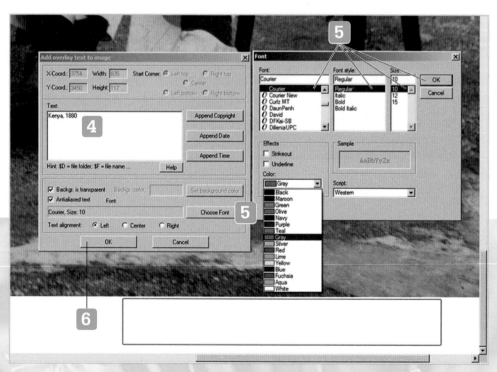

Scan a half-tone image

If you have an image from a newspaper clipping (like a wedding announcement or other published family image) you can scan and convert it by applying the descreening tool. Half-tone images from newspaper, magazines and books are made up of thousands of small dots but appear to the eye as continuous shades of grey. Most scanners will pick up the dots and leave a moiré pattern on your image if you don't adjust your scan.

In Epson Scan Professional Mode:

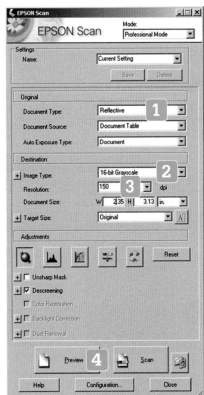

1 Select Reflective under Document Type.

2 Select image type (grayscale or color) under Image Type.

3 Select 150 dpi for resolution.

4 Preview the image and click Zoom in the Preview box.

5 Set the scan area by clicking on the auto marquee tool.

6 Click Descreening.

7 Scan and save your image.

! ALERT: You should not republish (on the Web or elsewhere) published images or text from newspapers, magazines or books without permission. The information here is for your personal use only.

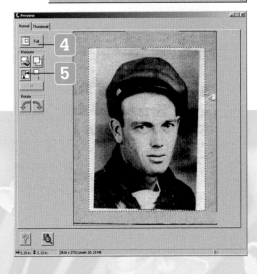

! ALERT: Scanning in lower resolution will reduce the number of dots but the image will also lose some sharpness. Experiment with scanning at a higher resolution to see if you prefer the results.

Scan an oversized image

Many scanner software packages now include special software to scan large images like photos, posters or maps. With the Epson software package a program called Scan-n-Stitch Deluxe is included as part of the bundle. To scan large images you will need to pull back the scanner lid in order to place the image correctly. Check your user guide for instructions on how to do this so you don't damage the lid or scanner.

1 Open Scan-n-Stitch.

2 Click on the image size you want to scan (Scrapbook Page, Long Page, etc.)

3 Place your image according to the instructions for that image size.

4 Click Scan Page.

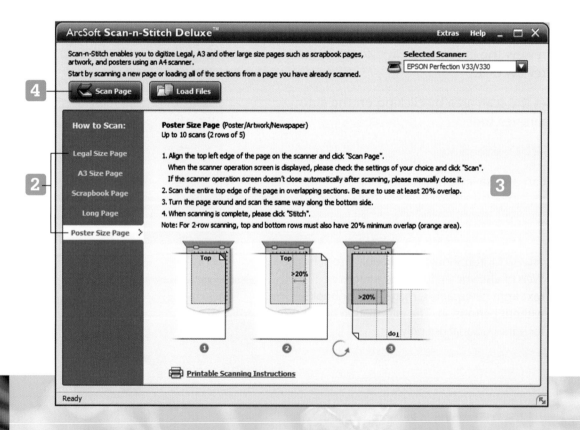

5 Select Document Type and Resolution.

6 Click Scan.

7 Repeat steps 3 to 6 for each section of the image.

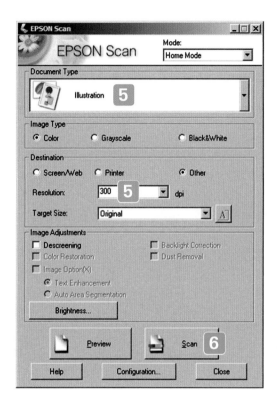

Stitch and save an oversized image

Once you have scanned all the sections for your image, you are just a few clicks away from having a complete image.

1 Click Stitch.

2 Select Single Row or Double Row.

3 Rotate your image if needed.

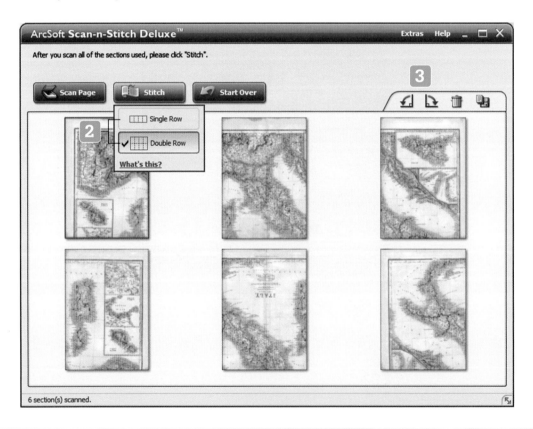

ALERT: If you have problems stitching the image together you may not have scanned enough of the image. There should be about 20% overlap in each scan section when you scan double rows.

HOT TIP: You can apply many of the same adjustments to posters, engravings and line art that you do to your photographic scans. View your stitched image in your editing software and make corrections as needed.

4 Click Save Page.

5 Name your file and save as either a JPEG or TIFF.

6 Click Save.

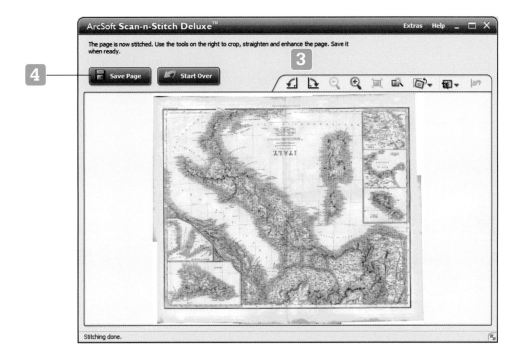

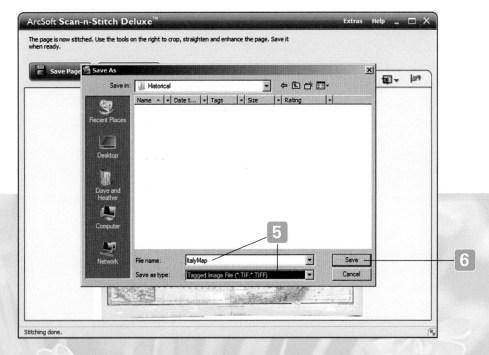

9 Organise your scans

Create a naming system 137

Set up folder options 138

Create new folders 139

Rename your files 141

Tag your images with Photo Gallery 142

Move images to a new folder 143

Copy images 144

Archive images to disc 146

Create an inventory for your disc 148

Convert file format 150

Introduction

After you scan a few decades' worth of photographs, your picture folders may be full to overflowing. Without a good system of organisation in place, it's easy to lose a file or save it in the wrong place. Most operating systems have a default folder structure which includes folders for documents, pictures, music and the like. You should save your images to the pictures folder or library which you might have, and create subfolders in that folder or library to organise your images. Finally, if your image files are taking up too much room on your computer, you can permanently archive them to a CD or DVD.

Create a naming system

Spend some time thinking about how best to name your images and folders so that it will be easy for you to remember which pictures are where. It may be easier for you to save by the date the photos were taken (e.g. July 2011) or you could choose some other method like sorting by holidays, birthdays or other life events. Use the tips below to help:

- Be consistent with the naming scheme you use; stick to one method whether it's by date or by event.
- Keep file names short.

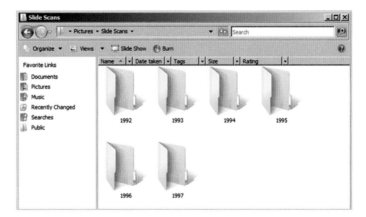

 HOT TIP: Keeping the file names short and consistent will make them easier to find later if you can't find a photo and need to do a search for it using your computer's search function.

 HOT TIP: When you organise your files, change the file view to thumbnail so you can see a preview of the image you are filing.

Set up folder options

Your operating system has its own default system for how folders open. It may be set to open only one folder window at a time. To make moving images between folders easy, you should check that you can open each folder in its own window.

1 Click Start and select Control Panel.

2 Double-click Folder Options.

3 Select Open each folder in its own window.

4 Click OK.

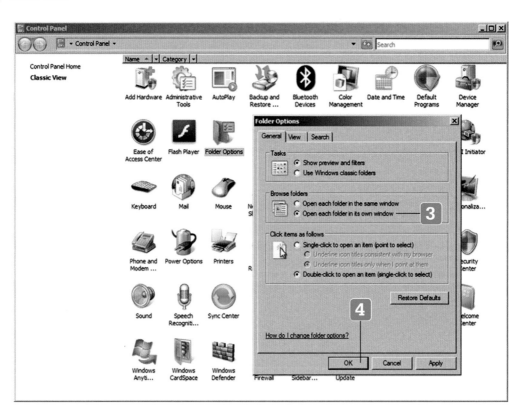

? DID YOU KNOW?

Your operating system may be set up slightly differently than the images above. Check that you are able to open each folder in its own window.

Create new folders

Most of your images will be in Pictures or My Pictures in Windows. You can choose to leave them there and create subfolders within Pictures to keep your images in. Avoid saving folders to your desktop as they will not be saved to your computer's hard drive.

1 Click the Start menu and Select Pictures.

2 Right-click in the open folder.

3 Select New and then select Folder.

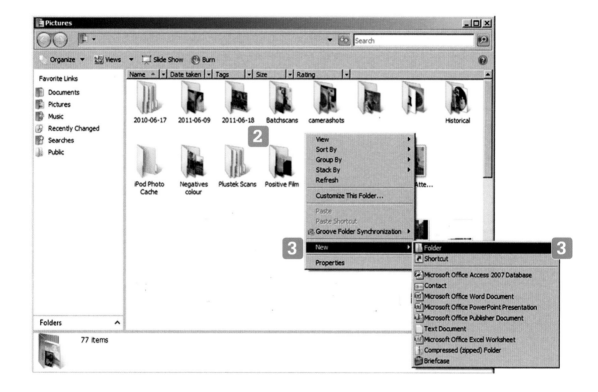

ALERT: If you create a folder you do not want to keep, you can right-click on it and select Delete.

4 Type a name for the folder and hit Enter.

5 View your files by icon or details by clicking on the Views tab.

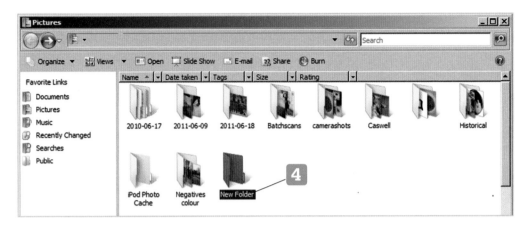

Rename your files

If you have a batch of images and are unhappy with the file name assigned to them, you can rename them all at the same time. You can also change a single file name using the steps below.

1 Open your folder.

2 Hold down the Ctrl key and click on each image you want to rename.

3 Right-click and select Rename.

4 Type in a prefix you want to assign to the batch of photos and press Enter.

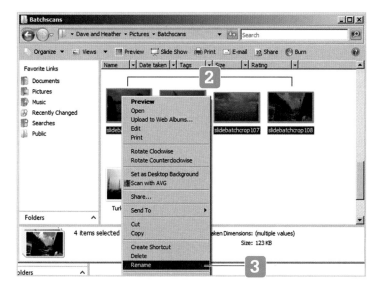

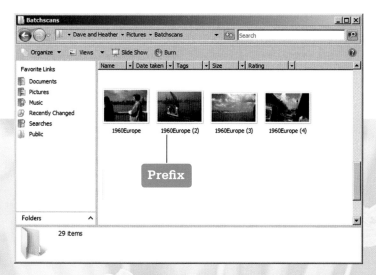

ALERT: The prefix name will be applied to all the selected images, they will be differentiated by number (Europe, Europe (2), Europe (3), etc.).

? DID YOU KNOW?
You can also rename a group of photos in Windows Photo Gallery and many other image editing programs.

Tag your images with Photo Gallery

Tagging is a way of labelling your image files with information about the picture such as when and where it was taken and who is in it. You can find your files more easily if they are tagged as you can search by file name as well as any tag you assign them.

1 Open your image in Photo Gallery.

2 Click on Add Tags.

3 Type in a tag and press return.

4 Type in any additional tags you want to add, hitting return after each one.

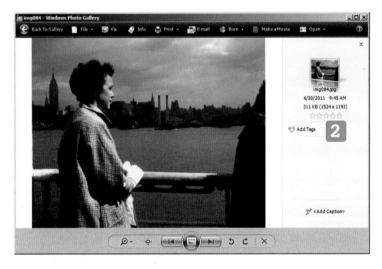

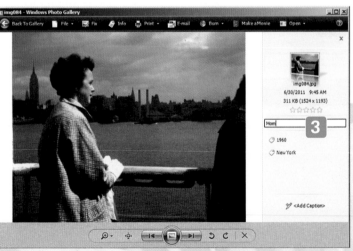

HOT TIP: You can add more than one tag to your image. For example, the person's name, date the picture was taken and the location.

DID YOU KNOW?
This option is also offered in many online photo organisers such as Picasa and Flickr.

Move images to a new folder

After you create a folder system to organise your scanned images, you can move them between folders to file them in the most logical place.

1 Open the folder that contains the images you want to move.

2 Open the folder you want to move the images into.

3 Hold down the Ctrl key and click on the images you want to move. The selected images should have a highlight around them.

4 Click and drag the group of images to the new folder.

5 Release the files in the new folder.

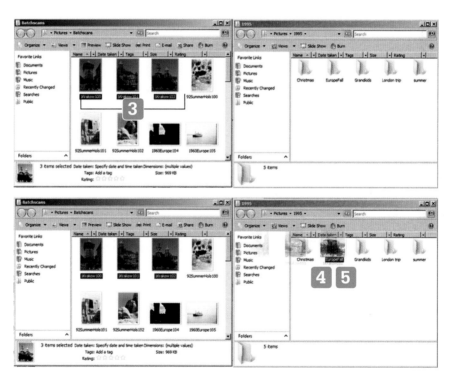

! ALERT: Make sure you don't release the files before you drag them completely to the new folder.

! ALERT: If you are moving images to a different drive, the images will be copied to the new location and the originals will remain in the same place.

Copy images

You can create copies of your scanned images and save them in different locations.

1 Select the images you want to copy by holding the Ctrl key and clicking.

2 Right-click and select Copy.

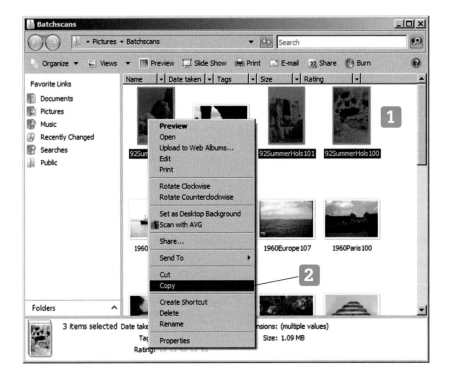

ALERT: Check you have copies of the images in both folders.

3 Click on the folder you want to copy your images to.

4 Right-click and select Paste. The images will appear copied in the folder.

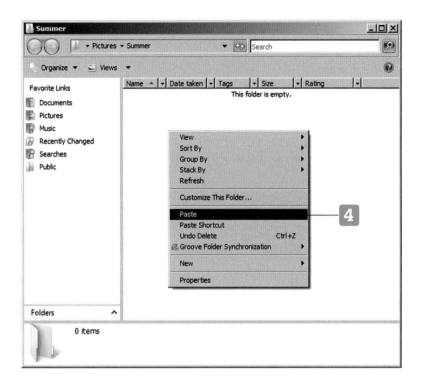

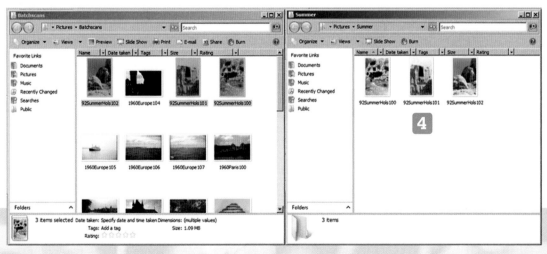

Archive images to disc

You can free up space on your computer by archiving your digital images to disc. Most Windows systems come with a Burn function which allows you to copy files onto disc. If you have a very large number of images you can save up to 4 GB of files on a DVD. If you want to save a smaller number of files, use a CD which only holds 600–800 MB.

1 Open the folder you want to save to disc.

2 Click Burn.

3 Insert a writable disc (like a CD-R) into the appropriate drive when prompted.

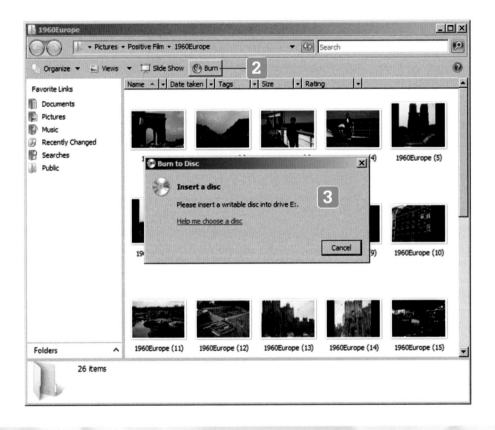

 HOT TIP: You can check the size of your folder by right-clicking on it and selecting Properties.

 HOT TIP: If room on your computer is very limited, consider deleting the images after saving them to two discs. Have two copies in case something happens to one of them.

4 Type in a name for the disc and click Next.

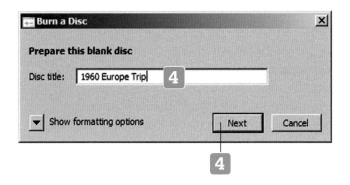

5 Wait while your images copy.

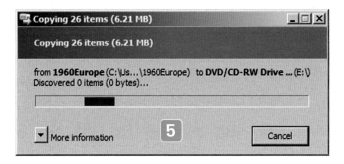

? **DID YOU KNOW?**

If you don't have a burn option on your folders, you can download free burn software. Use a trusted source like cnet (http://download.cnet.com/windows/cd-burners/) where you can see lots of options, reviews and editor recommendations.

WHAT DOES THIS MEAN?

Writable disc: one that has been formatted to allow you to copy files (images, music, etc.) from your computer. A CD-R is a type of writable disc that you can buy in most stores – including supermarkets – and is ideal for saving images.

Create an inventory for your disc

For a quick reference to the contents of your archive, you can print out the thumbnail views of the images on the disc. You can save a copy with your archive disc(s) and also print out a copy for your filing cabinet for future reference.

With the image of your folder's content on your monitor:

1 Click the Print Screen key on your computer's keyboard.

2 Open Paint from your Start menu.

3 Hold down the Ctrl key and press V to paste (or select Paste from the Edit menu).

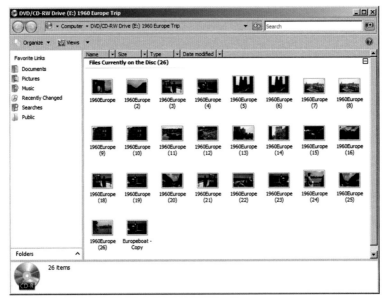

4 Click the crop tool and select an area to crop.

5 Hold down the Ctrl key and press X to cut the piece out you wish to keep.

6 Open Word, hold down the Ctrl key and press V to paste the piece in.

7 Save and print the thumbnails for your CD case.

Convert file format

If you saved files in TIFF and later decide you need to convert them to JPEG (or vice versa), you can do this easily to a batch of images – or even just one. Many photo processing centres require images to be in JPEG format for printing and other projects. Alternatively, you may decide to go back and edit an image further in which case TIFF is the better file format.

1 Open IrfanView and click Batch Conversion/ Rename.

2 Under Batch conversion settings select the Output format (JPEG or TIF).

3 Hold down the Ctrl key and click on the images you want to convert.

4 Click Add.

5 Click Start Batch.

6 Look at the window to check there were no problems with your conversion.

ALERT: The original will be permanently changed to the new format; the program does not save a copy of the original format.

10 Use your scans

Save to an SD card for use with a digital frame 155

Put photos in Movie Maker 157

Edit your photo movie 159

Save and share your movie 161

Publish your images on the Internet 163

Share your web album 165

Register with an online photo centre 167

Upload images for printing 168

Order prints online 170

Create photo gifts 172

Introduction

One of the advantages of having your photographs in digital format is the numerous ways you can use them. In addition to simply printing them out or emailing them to friends and family, you can use them in a digital photo frame, share them on the Internet and create videos. You can also use your photos to make custom photo gifts like photo books, calendars, greeting cards and more.

Save to an SD card for use with a digital frame

You can buy a digital photo frame for £30–£60 and enjoy a continuous display of your scanned images in a picture frame on your mantelpiece. Many require an SD card and some come with built-in memory but usually only enough for a few hundred photos. You can buy a larger card – up to 128 GB of memory (which is more memory than most PCs!) – and put a large portion of your favourite old photographs on it.

1 Insert the SD card into the appropriate slot on your computer.

2 Open the folder on your computer.

3 Open your saved scans in a separate window.

4 Hold down the Ctrl key and click on images to select them.

5 Drag and drop them into your SD card's folder

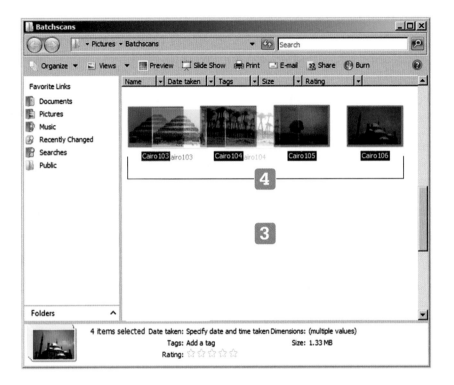

 HOT TIP: You can also hold down the Ctrl key and press A to select all of the images.

? DID YOU KNOW?
You can also take your images on the SD card to a photo centre to have them printed.

Put photos in Movie Maker

You can make a short movie of your images and add special effects and music if you want. Putting the images together is straightforward with the Movie Maker program that comes with most Windows operating systems. You can save your movie to your computer or save it to a disc to share.

1 Click on the start menu, select All programs and select Windows Movie Maker.

2 Click Pictures in the Import section.

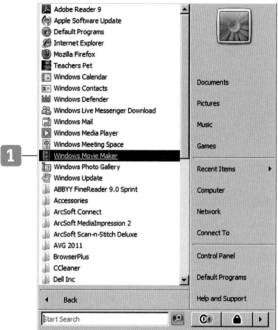

HOT TIP: You can put your photos in any order you want, you don't have to place them consecutively.

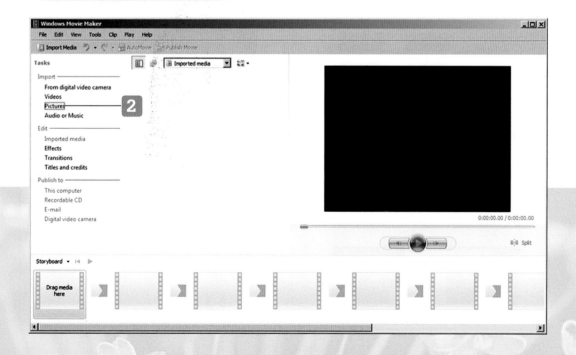

3 Hold down the Ctrl key and click on the images you want to include in your movie.

4 Click Import.

5 Click and drag the thumbnail images to the film strip (storyboard) below.

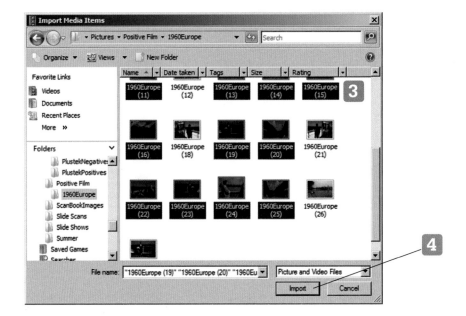

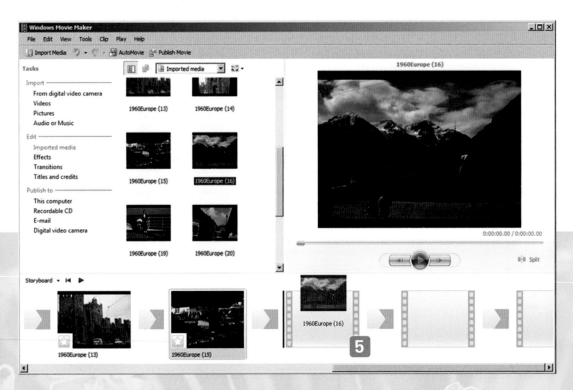

Edit your photo movie

After you choose the images for your video and have put them into the storyboard, you can add titles and other special effects to it.

With your storyboard open:

1 Click Transitions.

2 Click on a transition that you want and drag it between each of your slides.

3 In the Edit section click Titles and credits.

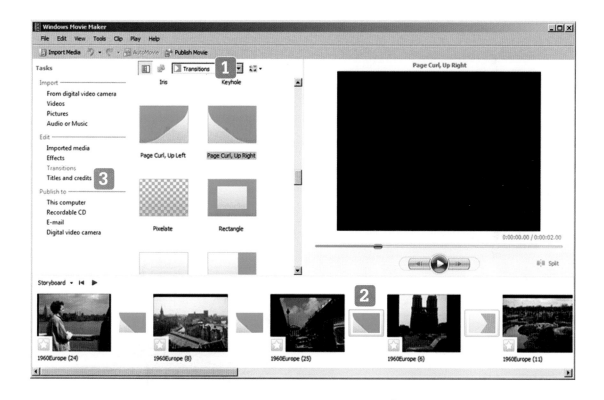

WHAT DOES THIS MEAN?

Transition: visual effect – like a turning page – that will happen between your photographs. It creates a visually interesting flow to your movie.

4 Select a title or credit to create.

5 Enter the text and change font and colour if you want.

6 Click Add Title (or Credit).

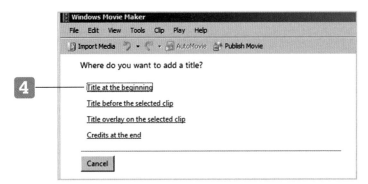

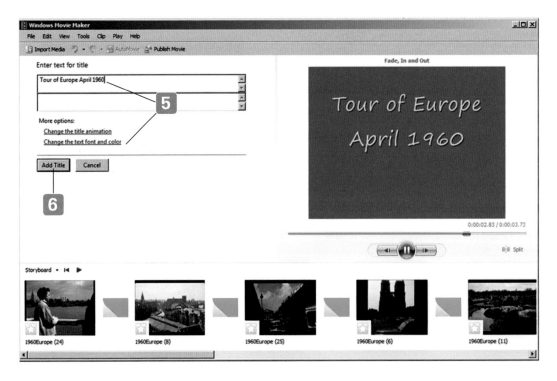

Save and share your movie

You can save your video to a CD-R, DVD or to your computer. You can also share it with friends through email or upload it to video sharing sites such as http://www.youtube.com.

To save your video to your computer:

1 Click This computer under the Publish to section.

2 Enter a name in File name.

3 Select a place to save by clicking Browse.

4 Click Next.

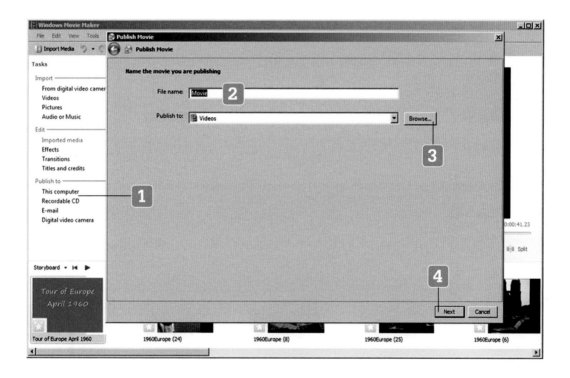

! ALERT: Videos made with Windows Video Maker save in the default folder, Videos, which is part of your computer.

? DID YOU KNOW?
If you are going to save your video to a CD, check that you have a writable or recordable CD.

5 Select Best quality … and click Publish.

6 Click Finish.

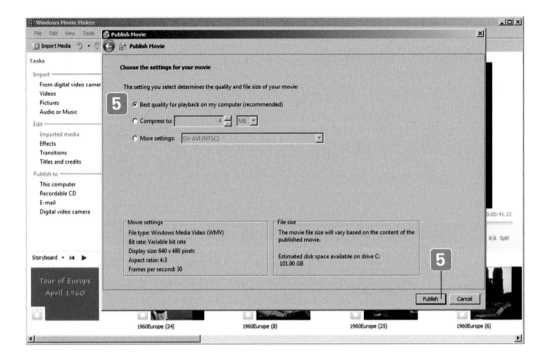

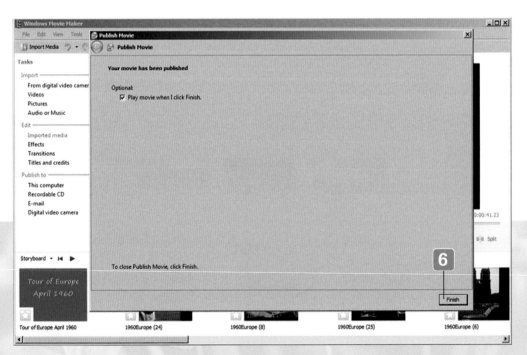

Publish your images on the Internet

If you downloaded a free image program like Picasa, you can upload your images and share them online with family and friends. (See Chapter 1 for instructions on how to download these programs.) If you have a Google email account you can sign in using that, otherwise you will need to register your email and other details in order to use Picasa Web Albums.

1 Double-click on the Picasa icon to launch the program.

2 Open an album or folder you want to share

3 Click Upload.

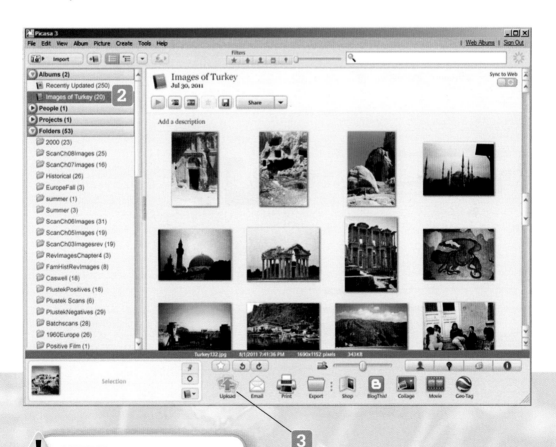

! **ALERT:** Picasa provides up to 1 GB of free storage space.

4 Select Anyone with the link under the Visibility for this album section. (Your album will only be visible to people you want to share it with.)

5 Click Upload to load the album to Picasa Web.

6 Wait while your images upload.

7 Click View Online to view your published album.

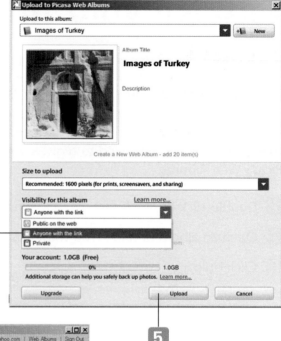

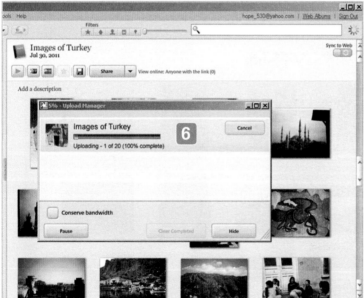

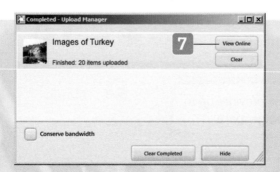

Share your web album

Once you upload your album, you can copy the link to your web album and email it to your family or friends. One advantage of doing this is that they don't have to open all your images in their emails – which can take a lot of time.

1 Go to the web album you want to share.

2 Click Link to this album.

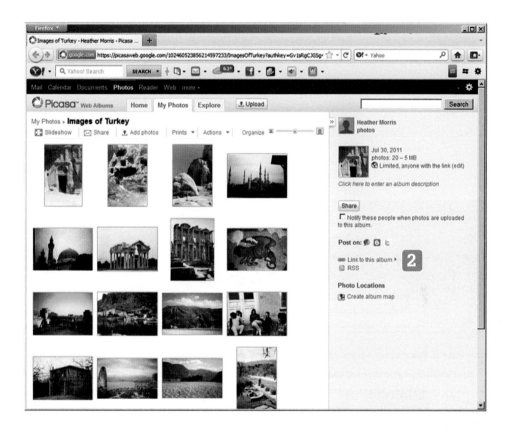

ALERT: Your recipients simply click on the link in your email to view the album.

3 Hold down the Ctrl key and press C to copy the link.

4 Open your email.

5 Hold down the Ctrl key and press V to paste the link into the email note.

6 Enter the addresses, write a note and send it.

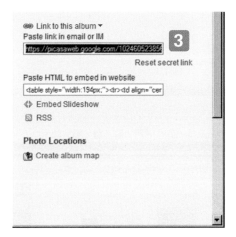

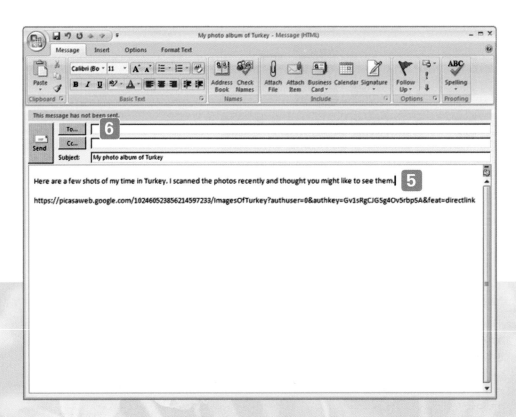

Register with an online photo centre

Many supermarkets and chemists have online photo centres. You can upload your images, and order prints as well as create other projects like photo books and calendars. Once you upload your photos and place your order, they either send the prints to you or you can pick them up in store at a given time.

1 Click Register.

2 Enter your details and a password for the site.

3 Read the Terms and Conditions and tick I accept.

4 Un-tick the newsletter option if you don't want to receive email.

5 Click Create Account.

ALERT: You must check your email and confirm by clicking on a link the photo centre sends you from within your email to be fully registered with the site.

HOT TIP: Registering with most photo websites is free – you are only charged if you order prints or other products.

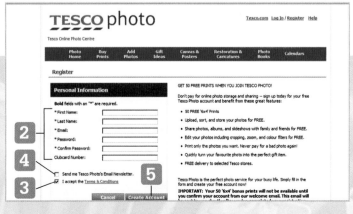

Upload images for printing

If you have a good Internet connection, you can transfer your images online to a photo centre of your choice. This means you don't have to go to the shop in person to place your order.

1 Click on the blank album.

2 Click on Browse to find the image(s) you want to be part of your order.

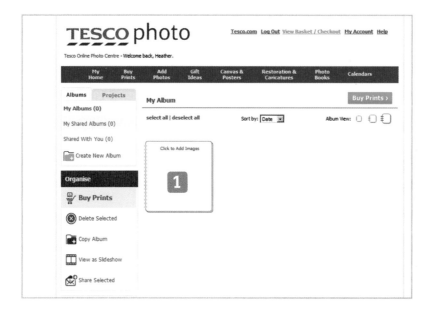

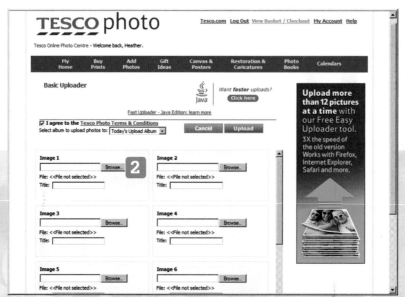

3 Double-click to upload it.

4 Repeat steps 2 and 3 until you select all the photos you want.

5 Click the Upload button.

6 Click through your album to check you uploaded all of the images you wanted.

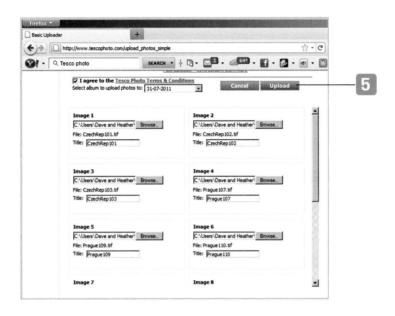

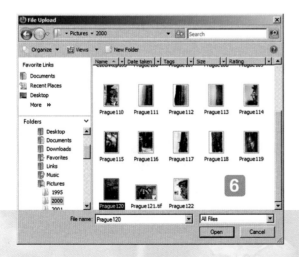

HOT TIP: Consider downloading the Fast Upload option on the site. You can upload more images at the same time and it's faster. Follow the instructions for downloading this utility and follow the prompts to install it.

HOT TIP: You will need a fast (preferably broadband) connection to the Internet or uploading your images may take a long time.

Order prints online

Once you have uploaded your images to the site, place an order for your photographs and choose whether to pick them up at a local store or receive them in the mail.

1 Double-click on your album.

2 Tick the images you want to print.

3 Click Buy Prints.

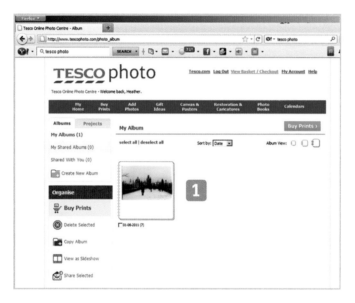

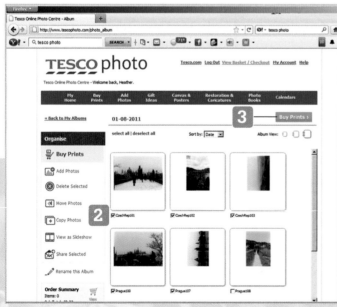

ALERT: Nowadays all reputable photo centres offer safe online transactions. You should see the http in the web URL change to https (a more secure location).

4 Click Add & Go To Basket.

5 Select the quantity and size for each image.

6 Click Continue to Checkout and follow instructions for completing and paying for your order.

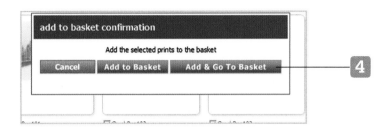

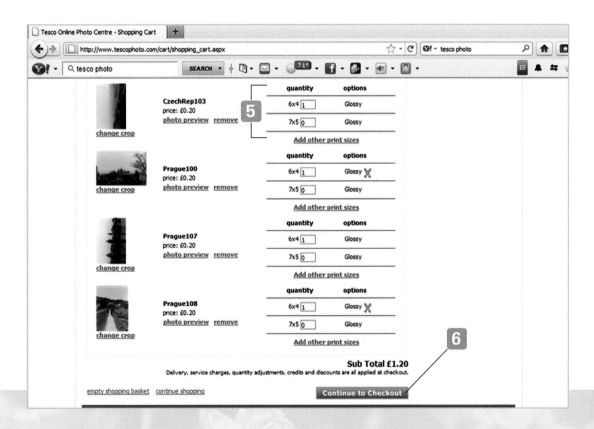

ALERT: To place an order, you will be asked for your credit card number, valid from/to dates and the three-digit number in the signature strip. You should never be asked for your bank account number or sort code.

Create photo gifts

If you have your scanned images saved to an SD or other memory device, you can take them to a photo centre and have a gift like a photo book or card made with your images. Alternatively, you can order projects like these with your online photo centre account.

Other gift ideas include:

- Create greeting cards with a favourite picture for use as a birthday, holiday or thank you card.
- Make a calendar with your best holiday shots.
- Have a large canvas print made of a photograph.
- Use your images on key rings or bags.

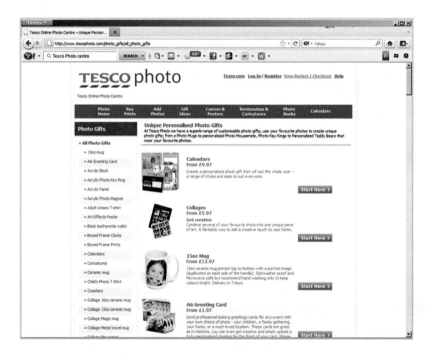

! ALERT: You will need to upload your images to the site prior to starting a project.

! ALERT: Some online photo centres require you to download a simple software program. Most are free and simple to download. Check that you have room on your computer and then follow the instructions for set up.

Top 10 Scanning and Restoring Problems Solved

1 I'm getting a message that says my scanner isn't recognised or connected 174

2 My previewed scan has the wrong scan area around it 176

3 I can't batch scan my photographs 177

4 My scanner is slow or not working properly 178

5 My scanned photograph is blurred 180

6 It's difficult to make out details on my monitor 181

7 I'm not happy with my scans of black and white photographs 183

8 I can't repair my damaged older photographs 185

9 I want to resize my image to send it via email 186

10 I'm running out of memory on my computer 188

Problem 1: I'm getting a message that says my scanner isn't recognised or connected

When you first set up your scanner, it isn't uncommon to get an error message saying your scanner is not recognised or connected. Check all the connections between the scanner and your computer (USB port, cables, etc.), ensure the power cord is connected to a working electrical outlet and do the following:

1 Click the Start Menu and select Control Panel.

2 Double-click Device Manager.

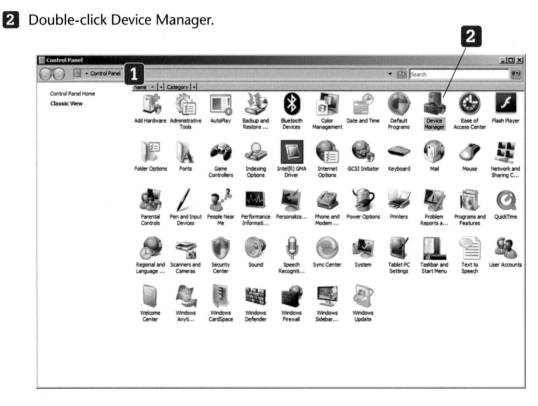

3 Click on Imaging devices and click on your scanner.

4 Click on Action.

5 Select Enable.

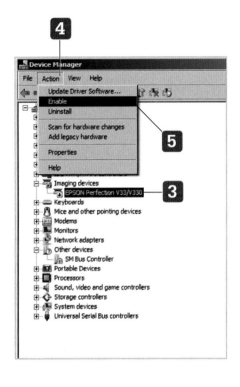

ALERT: If you are using more than one device, you first have to disable the other device before you can connect your scanner to your computer. Click on Action and select Disable to disable a different device.

Problem 2: My previewed scan has the wrong scan area around it

As you switch between scanning larger and smaller photographs, you may notice that your preview displays a scan area or crop that does not match the photograph you are scanning. Many programs apply the last settings you used to your current scan. You have to manually alter the scan area each time you scan.

1 Click on the marquee erase button.

2 Click the auto marquee button.

3 Adjust the marquee as needed.

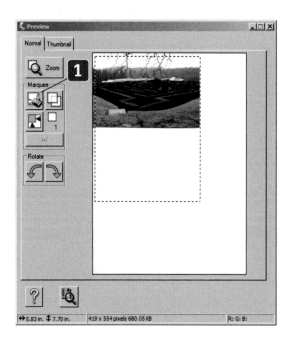

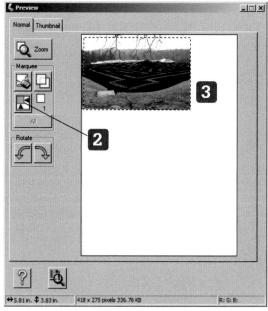

Problem 3: I can't batch scan my photographs

You may need to experiment with the amount of space between your photographs. Some scanners require more room between images for the batch scan to work properly. It may also be that your scanner does not support batch scanning.

1 Move your photographs so that they are at least 5mm apart.

2 Check that you have set the scan area (marquee) around each photograph.

3 Click All in the Preview window once you have set the marquee for each photo.

4 Click Scan to check they scanned as separate files.

5 Adjust the space if necessary or place fewer photographs on the scanner's bed.

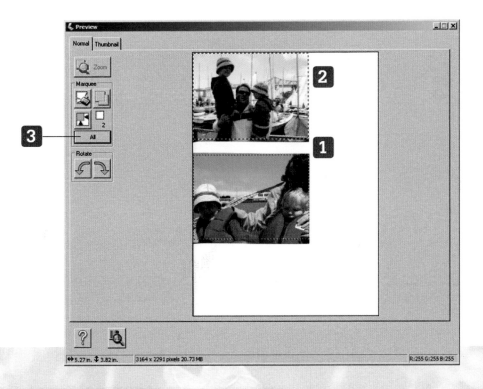

HOT TIP: Check with your user's guide or the manufacturer's website for information on your scanner's batch scanning capabilities.

Problem 4: My scanner is slow or not working properly

You may find that over time your scanner works less efficiently than it did previously. If so, you may need to update your scanner's driver. The driver is a type of software file that keeps the scanner and your computer working well together. Manufacturers frequently update the driver to improve the function of the scanner and resolve any bugs or other common problems.

1 Click on the Start menu and select All Programs.

2 Select Windows Update.

ALERT: Windows may not be able to locate an update for your driver. If you don't see an update for your scanner, you may have to go to the manufacturer's website and locate the update yourself, then install it manually through the Device Manager.

3 Click Check for updates.

4 Click Install updates if there are updates available.

5 Click Restart when prompted to do so.

 HOT TIP: Windows Update also checks for updates to your other hardware devices. It's a good idea to keep all of your hardware up to date to keep your computer working smoothly.

Problem 5: My scanned photograph is blurred

Occasionally an image will appear blurred or distorted in some way when you first preview it. First check that the photograph was placed completely flat on the scanner's glass. After you check the position, you can try some or all of the following adjustments to help improve the image.

- Select the Auto Exposure adjustment in preview.
- Increase the resolution of the image.
- Select the Unsharp Mask option while your image is in preview.

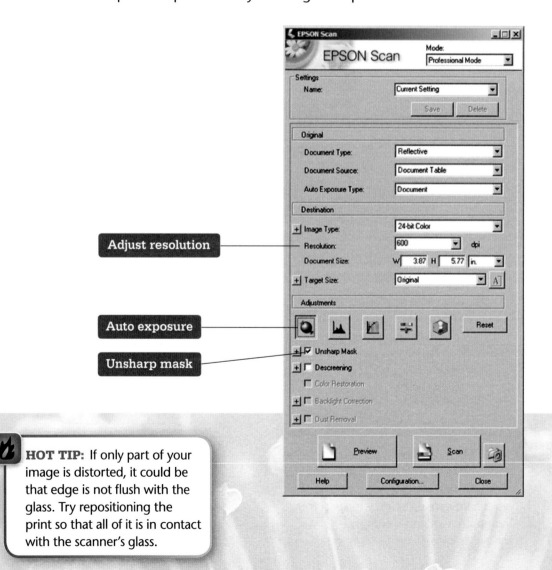

Adjust resolution

Auto exposure

Unsharp mask

HOT TIP: If only part of your image is distorted, it could be that edge is not flush with the glass. Try repositioning the print so that all of it is in contact with the scanner's glass.

Problem 6: It's difficult to make out details on my monitor

Most computers have a default setting to maximise the amount of detail you can see on your type of monitor. If for some reason these settings are altered, you can manually adjust them to improve the detail and depth of colour you see on screen.

1 Click on the Start button and select Control Panel.

2 Double-Click on Personalization.

? DID YOU KNOW?

Personalization may be referred to as Appearance and Personalization on your computer.

3 Click Display Settings.

4 Adjust Resolution to High and select Highest under Colors.

5 Click Apply.

6 Click Yes when asked if you want to keep the settings.

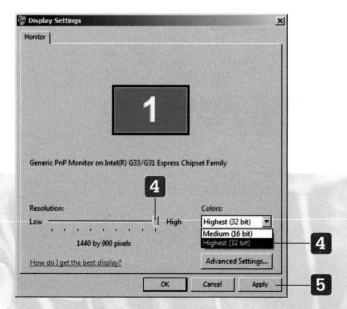

Problem 7: I'm not happy with the scans of my black and white photographs

Sometimes the grayscale option on scanners does a poor job of picking up all the tones in an image. If you find that you are unhappy with your black and white scans, you can experiment with scanning them in colour to try and pick up more tone and improve the image overall.

1 Place your black and white photograph in the scanner.

2 Select 24-bit Color under Image Type and preview the image.

3 Adjust the histogram information and scan.

4 Open the image in your image editing program.

5 Select Color Effects.

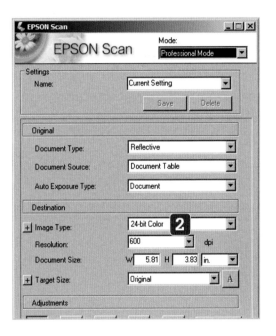

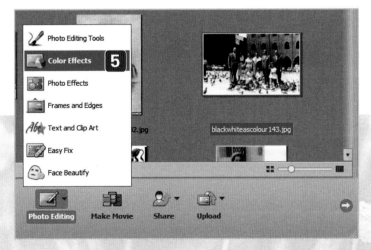

6 Click on the grayscale effect.

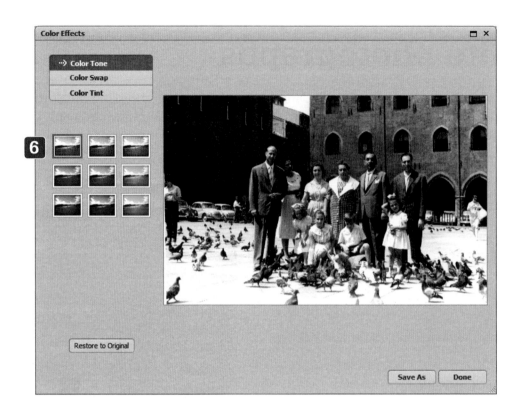

SEE ALSO: See Chapter 8 for information on evaluating and adjusting the histogram.

Problem 8: I can't repair my damaged older photographs

It may be that the repairs are beyond the ability of the average scanner and software package. Sometimes scanners can exaggerate the damage in your photos. You can try to take a picture of your photograph with a digital camera. Cameras with the ability to take close-up shots work best.

1 Set the digital camera on an even surface or use a tripod to keep it steady.

2 Place the image on a completely flat surface.

3 Take the picture near a natural source of light.

4 Transfer the image file to your computer and edit it as you would a scanned image.

! ALERT: Avoid direct sunlight and check that your camera's flash is turned off.

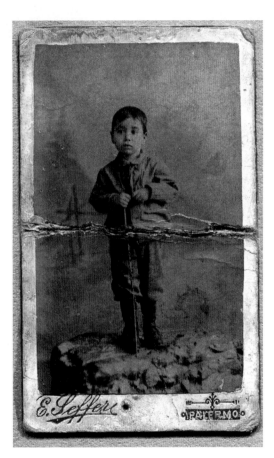

 HOT TIP: Use more advanced editing techniques to work on older photographs including histogram adjustment and the healing brush. See Chapter 8 for a review of how to do this.

 HOT TIP: If you don't get the results you want with the digital camera and your editing software, consider using a professional restorer to work on your valued older prints.

Problem 9: I want to resize my image to send it via email

You may have saved a file in higher resolution so you could edit or print photographs. You won't need the same resolution for web use or to send via email and can change the resolution of your images after you scan with Windows Photo Gallery.

1 Open your picture in Windows Photo Gallery.

2 Click Email and select Smaller size.

3 Click Attach.

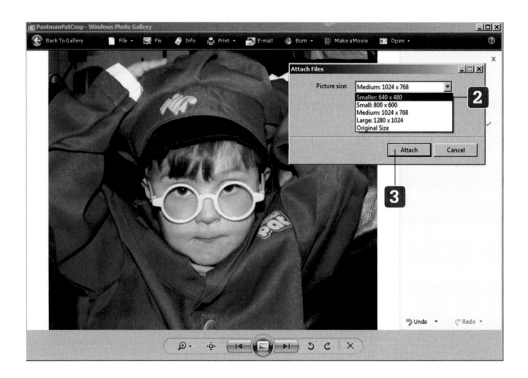

4 Type in the recipient address and write a note if you want.

5 Click Send.

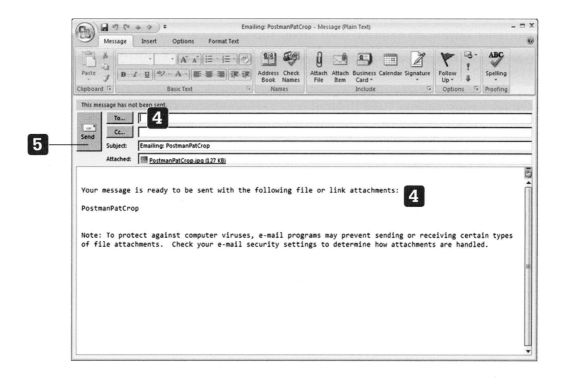

? DID YOU KNOW?

Most image editing programs come with a Resize tool. With your image open in the program, select Resize and enter a smaller resolution for your image (e.g. 150 dpi).

Problem 10: I'm running out of memory on my computer

If your computer is starting to slow down because you have a large number of image files, consider buying an external hard drive. You can safely save all of your scanned photographs to an external drive for about £40–£60. The drive sits next to your computer in a separate container and can store from 160 GB to 1000 GB of data.

1 Connect your external hard drive to your computer with the connection cable that came with it.

2 Click Start and select Computer.

3 Locate your external hard drive and double-click on it.

 HOT TIP: You need to delete the pictures on your computer's hard drive to create additional space and improve your computer's functioning. Check that you have transferred all the images you want to before deleting any from your hard drive.

4 Open your Pictures or My Pictures folder to find the images you want to move.

5 Copy the images (press Ctrl C) you want to move.

6 Paste the images into the external hard drive window (press Ctrl V).

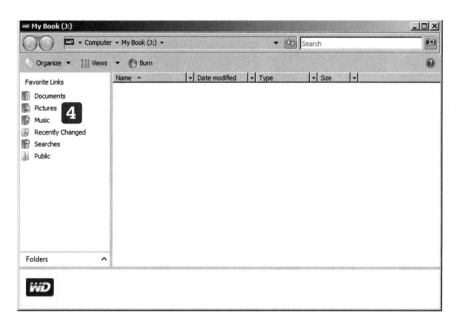

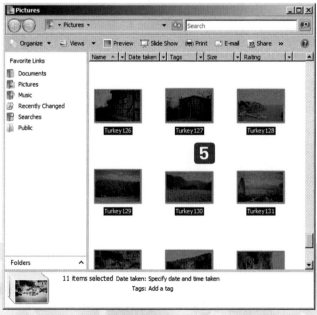

Also available in the
In Simple Steps series

Digital Photography

9780273723516

Build your First Website

9780273745419

Computer Problems Solved for the Over 50s

9780273746355

Editing, Storing & Sharing your Digital Photographs

9780273744146

Photoshop CS5

9780273736820

Windows 7

9780273729136

Researching your Family History Online

9780273761099

Social Networking for the Over 50s

9780273761075

Photoshop Elements 10

9780273771296

Using your Digital SLR Camera

9780273761105

Laptop Basics Windows 7 Edition

9780273736806

Using the Internet for the Over 50s

9780273734932